IMAGES
of America

PLAYLAND

On the cover: What child can resist a pony ride? For the cost of 10¢ a child can hop on a pony and ride around between the white picket fences. As they ride past the roller coaster the excited screams can be heard from the riders as the cars plunge down the 80-foot dips and race around the curves at a speed of 100 miles per hour. Additional horseback riding will soon be available along the paths around Manursing Island for the adults to enjoy. (Courtesy of the Westchester County Archives.)

IMAGES
of America

PLAYLAND

Kathryn W. Burke

ARCADIA
PUBLISHING

Published by Arcadia Publishing
Charleston SC, Chicago IL, Portsmouth NH, San Francisco CA

Printed in the United States of America

Library of Congress Catalog Card Number: 2007924611

For all general information contact Arcadia Publishing at:
Telephone 843-853-2070
Fax 843-853-0044
E-mail sales@arcadiapublishing.com
For customer service and orders:
Toll-Free 1-888-313-2665

Visit us on the Internet at www.arcadiapublishing.com

*In memory of my brother, William D. Wilson III (1957–2007), who loved
all amusement parks and spending his time with family and loved ones.
Bill, you are greatly missed.
As always, whatever I do is dedicated to Walter, Maureen, and Kate.*

CONTENTS

ACKNOWLEDGMENTS

The following people deserve many thanks for their assistance in making this book possible: Westchester County Executive Andrew J. Spano for contributing the foreword for this book and the following individuals from the Westchester County Archives: Patricia Dohrenwend, director; Elaine Massena, principal archivist, who provided vast amounts of knowledge and assistance in research and support; Cindy Sauer, assistant records manager; Jackie Graziano, reading room manager, who although relatively new to the position was a great deal of help to this author; Christine Hogan, supervising records clerk; Trish Foy, reading room specialist; Larry Auerbach, volunteer; Nel McDonald, volunteer; and last but not least, Muriel Weiss, volunteer and role model for us all for her example of continued dedication to helping others. All but a very few private photographs come from the Westchester County Archives. Thanks also to Barbara Clay for her continued expert legal advice. I am especially thankful for continued love and support from my family, Walter, Maureen, and Kate. I would also like to acknowledge the following young individuals and encourage them to follow their dreams: Nicholas, Erin, Christiane, Olivia, Alexandra, Carissa, Alexas, Casey, Elizabeth, Matthew, Patrick, Edward, Brian, Richard, Tonimarie, Isabella, Timothy, Jared, Sean, Nichole, and Jonathan. Lastly, Tiffany Howe, my editor from Arcadia Publishing, always ready to answer questions and give assistance.

FOREWORD

Playland is, without a doubt, the most nostalgic family amusement park in the nation. With its unique history and special place in our hearts, we can safely say there is nothing else like it—anywhere.

For as long as I can remember, Rye Playland has been a part of my life. I was about five when my father took me for my first visit to Kiddyland and to ride the paddleboats. Six decades later, I have done the same with each of my own four children and am continuing the tradition for my grandkids. We even go on some of the same rides I went on as a child!

A trip to Playland was always a special occasion in our family. We still talk about playing on the beach and trying to squeeze as many rides as possible into an afternoon. Even today, if I have something on my mind, I like to unwind by taking a stroll along the boardwalk.

I call the park "the Memory Maker" because so many people—almost one million each summer—have fond memories of their days at the park. In fact, Playland has been the most visited site in the county park system since its opening in 1928, and that is just what the far-thinking individuals who built it had in mind.

Back in the 1920s, there was a unique vision of what a great park should be. Two deteriorating properties were transformed into a family park that did not charge admission and offered a beach, boardwalk, bathhouse, pool, and ice skating. The rides were an afterthought to pay the bills. The founders knew they were not creating an amusement park; they wanted a park with amusements in it.

Today Playland boasts an unusual status. Not only is it a national historic landmark, it is America's only government-owned amusement park and a prototype for other theme parks around the world.

As the county's chief elected official, it is my responsibility to help preserve this historic treasure and bring it back to its heyday. We have a long-range plan that will guide its operation and are moving forward with plans for a children's museum in the now-closed bathhouse.

I hope people will still be bringing their families to Playland and making their own memories 100 years from now, and I hope the county executive at that time will continue to recognize the park's unrivaled historical and community significance.

—Andrew J. Spano

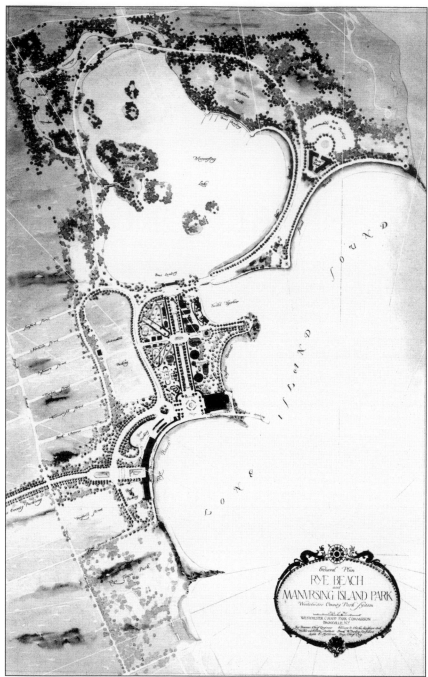

The Westchester County Board of Supervisors, the governing body in the 1920s, along with the Westchester County Parks Commission, determined to provide the citizens of Westchester County with a parks system to rival Central Park, embarked on a revolutionary plan to build a publicly owned amusement park and resort. The rendering above is the general plan for the Rye Beach and Manursing Island Park that would come to be called Playland. Most of the plan was brought to fruition and remains an important place for recreation in Westchester County today.

INTRODUCTION

In 1922, with the population of Westchester County around 350,000, the Westchester County Board of Supervisors created the Westchester County Parks Commission for the purpose of providing the location, creation, acquisition, and improvement of parks, parkways, and boulevards in and by the county of Westchester. The visionary move by the board of supervisors would create in Westchester County a system of parks and parkways that would become world renowned. The most unique and impressive part of this system was and still is Playland.

Through a prolonged series of steps and over a number of years, Westchester County acquired control of some 214 acres of property in Rye, New York, along the Long Island Sound. A plan was put in place to develop parts of that property for a beach and bathhouse, an inland lake and boathouse, a midway containing a variety of amusements, a casino for a variety of uses, and a boardwalk with breakwaters and a shipping dock. The plan was developed by Frank Darling, expert in the field of developing amusements and amusement parks; Maj. Gilmore D. Clarke, parks commission head and landscape architect; park engineers L. G. Holleran and Jay Downer; lighting engineers Watson and Flagg; and the award-winning architectural firm of Stewart Walker and Leon Gillette, famed for art deco buildings.

Westchester County operated the old Rye Beach Amusement Park for the summer of 1927. Then the day after Labor Day in 1927, buildings and old amusements were razed to make room for the new Playland. Work was completed in record time, and cost was not spared. The intent was to create the best amusement park and beach resort in the world. But not just any amusement park and beach resort, a publicly owned park. It would be a park that offered a clean, family-fun place to spend the long summer days. It would be a park that was aesthetically beautiful, wonderfully clean, and offered every imaginable type of entertainment from amusement rides to circus acts to beautiful beaches and bathhouse to restaurants and areas for leisurely relaxing.

Playland became that kind of park. Record-breaking crowds arrived and stayed that first summer in 1928. And Playland continued to improve. The next year brought the Olympic-size swimming pool and the casino, which would enable Playland to become a year-round resort. The likes of Frank Darling and Frederick Church kept the park thriving by designing and acquiring newer and better amusements. Contracts with exceptional concessionaires kept the park financially successful. Even the Great Depression did not greatly affect the activities at the park. People continued to come to the park hoping for and getting a little escape from life's worries; they just were not able to spend as much money. The park answered that need by briefly lowering costs. There was a brief lull in the park admissions when the world's fair was in New York in 1939, but attendance rebounded.

During World War II, rationing and the war situation caused changes at the park. Gasoline-driven amusements were closed. The Ice Casino did not open for three winter seasons,

and the park began its practice of closing on Mondays. Additionally, preparations were made for air raid drills and blackouts, not something easily done in an amusement park. The federal government took inventories of trucks and boats on the premises and eventually appropriated some equipment for the "war effort." Many concessions were transferred as men joined the military. As the war was coming to an end in the summer of 1945, plans were made to reopen for the winter season. Sprucing up of the park was needed, and in some cases major overhauls of amusements were necessary. Buildings and rides were repainted, and as in the past, thousands of bulbs, flowers, and many new trees were planted to make ready for the summer season.

The postwar years began a new age for Playland. The park began to go through a period that reflected the country's desire for newer and better things. This book looks primarily at the early years of the park with a few nods to things that remained the same even into the 1980s. Some photographs are of the years during the war, but another book would be needed to examine the later years.

As a Westchester County resident for many years, I have been to Playland many times. I went as a young adult with friends. I went with my young family and my mother and siblings and their families on what would have been my father's 70th birthday to celebrate my father's life in a fun way with my family. And my husband, Walter, and I have taken our daughters many times over the years because we always had such a great time. Now they go with friends and experience Playland the way I first did as a young adult. Playland is a wonderful tradition to pass down to our children. I hope it will be here for my grandchildren and their children.

Hopefully this book will take people back to a different time for Playland. In researching information for this book, I came to realize the history of what made Playland is noteworthy. Playland and the Westchester County Parks System is one of the main things that sets Westchester apart from other similar communities. While the population continues to grow and development keeps pace, we will always have the open spaces, the large pockets of green recreation areas, and Playland with its wonderful location on the Long Island Sound to enjoy.

One

CONSTRUCTION

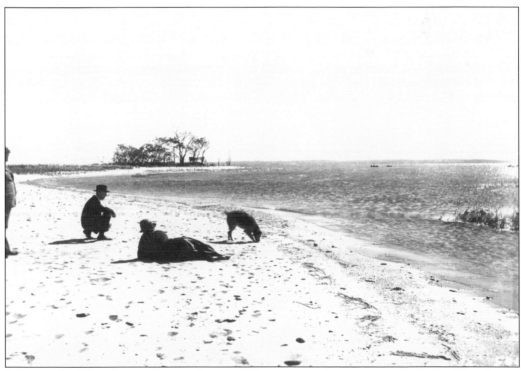

In 1923, the Westchester County Board of Supervisors, the governing body for Westchester County at that time, authorized $600,000 for the purchase of 160 acres of property on the Long Island Sound around what was then known as Manursing Island. In 1925, the supervisors authorized an additional $2.5 million for the purchase of an additional 54 acres at Rye Beach. This parcel of land was considered to be the largest available tract and practically the only available undeveloped beach property of any consequence along the Long Island Sound front. These purchases combined with the eventual purchase of two existing amusement parks in Rye would become, in 1928, Playland Amusement Park.

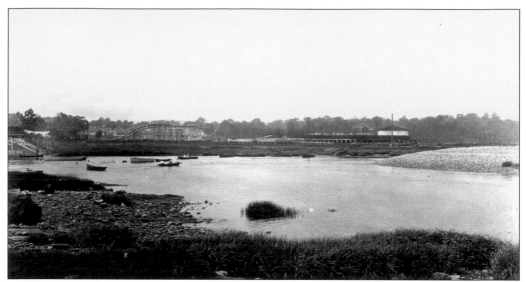

The area behind the shore strip contained marshland and swamps. It was a breeding ground for swarms of gnats and mosquitoes. The park plan called for a cleaning up of the outside beach and dredging of the marsh to create a deep, interior lake of about 80 acres for pleasure boating and other water sports, as well as adding fill to the low areas to enable further development of the amusements.

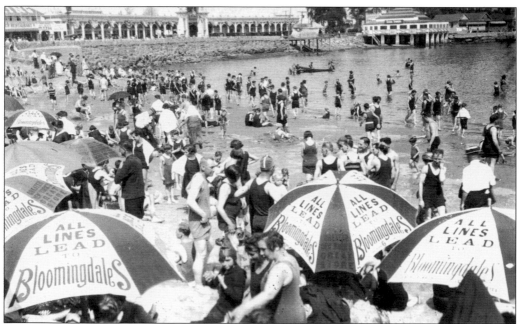

In an article in the *Bronx Record Times* in July 1923, Rye Beach Pleasure Park was described as a mecca for Bronx residents escaping the heat. The park covered 20 acres and had excellent beach and bathing facilities, as shown above. It also offered amusement rides such as a carousel, the Whip, a large roller coaster, and many other attractions. The Beach Hill Inn, shown in the top right of the photograph and in a close-up on the next page, was a very popular eating spot. Miller's bathhouse runs along the rest of the top of the photograph and can also be seen in a close-up on the next page.

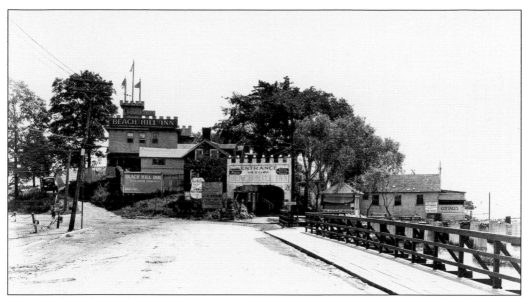

The Beach Hill Inn shown above was located on a 1,500-foot elevation commanding a clear view of the Long Island Sound. A 10-piece jazz orchestra was said to drive away "dull care." Signs outside the inn advertised shore and chicken dinners, music, and dancing. The Beach Hill Inn stood on the location where the Westchester County Parks Commission would build the Playland Casino.

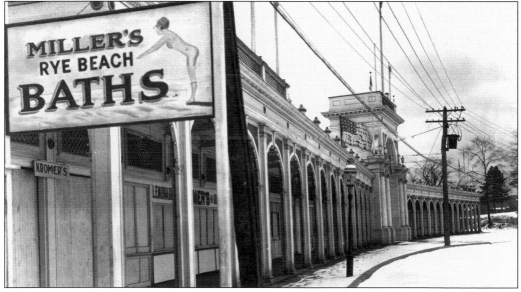

A new law making possible a park extension at Rye Beach was signed in June 1923 by Gov. Alfred Smith for Rye to access Oakland Beach waterfront and immediately contiguous land into a public park by purchase or condemnation of land. This law gave the Westchester County Parks Commission power to acquire, re-layout, and add to the present town park with the privately owned bathhouses, cottages, automobile parking areas, refreshment stands, including the ferry pier advertisement buildings just south of the present town park. Miller's Rye Beach Bathhouse was situated on the land that would become the boardwalk between the casino and the Playland Bathhouse.

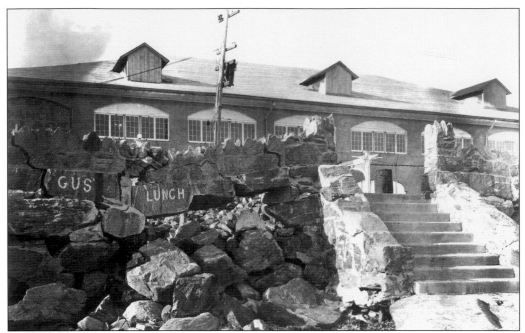

Gus's luncheonette, seen above, was open year-round and is located at the entrance to the Rye Beach Pleasure Park. It faced the beach and is on the location of the future Playland Bathhouse. Gus's luncheonette was owned by Augustus Rosasco. Gus would become one of the major concessionaires at Playland, supplying most of the gaming rooms and arcades, at one time holding over 25 concessions.

The entrance to the Rye Beach Pleasure Park can be seen in the above photograph. It was for many Rye Beach residents the site for protests organized against the Pleasure Park and Paradise Park, due to the level of noise said to be so bad that sleep was impossible until well after midnight. Concern of the residents was so great that in March 1924, Supreme Court justice George H. Taylor Jr. of Mount Vernon heard testimony about the roller coaster noise by some 100 witnesses.

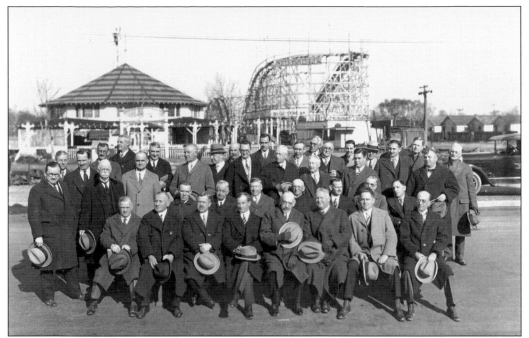

Rye residents were greatly in favor of the Westchester County Parks purchase of the Rye Beach area. Through petition they urged the purchase of all land between the Rye town beach and Oakland Beach, including the Beach Hill Inn and the existing amusement parks, doing away with private amusements and making the land available for use of the county under exclusive control of the parks commission. The Westchester County Board of Supervisors, pictured above, inspected the acquisition.

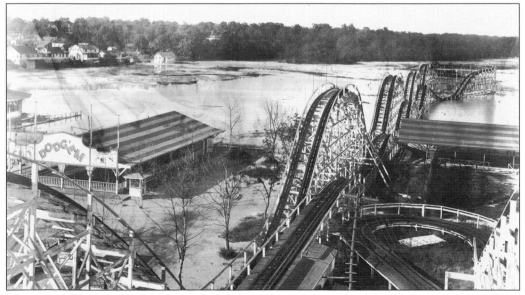

The giant Blue Streak roller coaster boasted a mile-a-minute ride with eight monster dips. From the above photograph, it is easy to see why the homes, located just a little distance from the giant coaster, would hear not only the roar of the cars as they raced along the track but the excited screams of the terrified passengers.

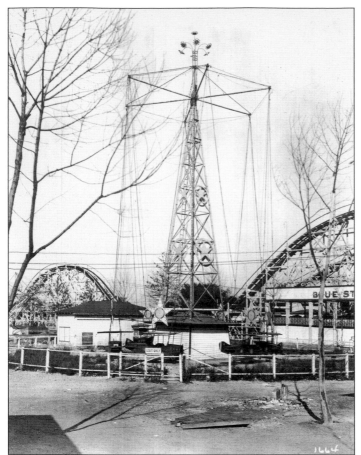

The Airplane Swing would be sold to provide a new similar ride for Playland along with several other popular attractions such as the Dodg'em bumper cars and the Whip pictured below. It is also evident from the photograph that while a popular place for amusement the park was not well kept. The area was dusty and littered, making it an uninviting place for families with young children. The intent of the Westchester County Parks Commission was to provide a clean, attractive family park without the rowdiness of the previous amusement areas.

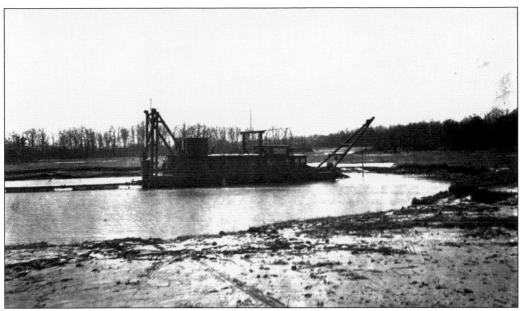

The Trimont Dredging Company was hired to create the interior lake. Work began in early 1926. Fill dredged from the swamp and the salt meadows was added to the proposed amusement areas, raising the ground above a level that had previously flooded. The Manursing Island Lake was created to provide a calm-water area for boating and other water sports.

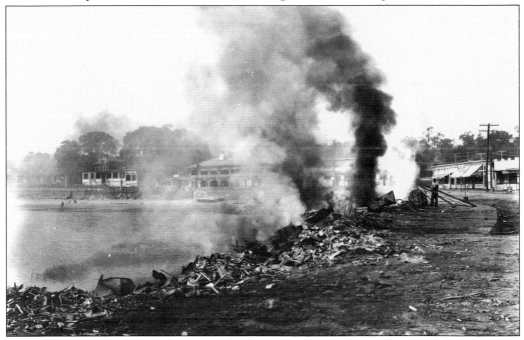

Rubbish burning on the beach area in the above photograph is from the initial destruction of existing buildings to make way for the clean, new Playland Park. Backhoes began dismantling the old buildings the day after the park closed for the season in September 1927. This littered waterfront, in just a few months time, will become a pristine, sandy beach surrounded by two curved breakwaters and an extensive boardwalk, the first for Westchester County.

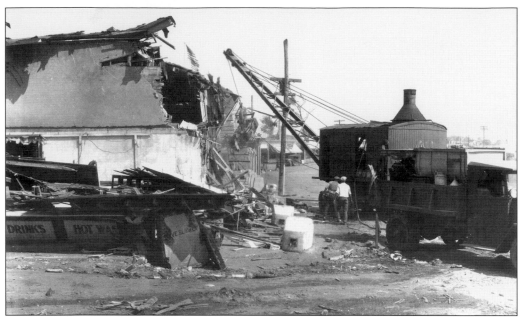

Buildings that held no salvage value were razed by the dredging bucket hanging off the crane pictured above. An American flag still flies above the next building to be razed. Gus's luncheonette waits its turn just down the beach to make way for the new Playland Bathhouse. Evidence of their existence is fast disappearing. The sign proclaiming the future home of Playland Amusement Park can be seen in the distance to the right of the newly built roller coaster.

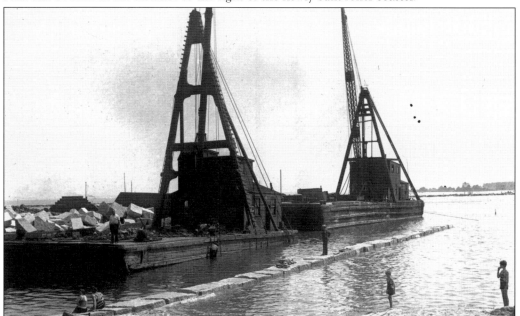

Breakwaters are being constructed, like two arms projecting out from the beach area, to provide a protected environment for bathers and reduce the potential for wave damage during heavy storms or hurricanes. The two crescent-shaped breakwater boardwalks pictured above are being made of granite blocks weighing three to five tons each. Children can be seen on the shore watching the work.

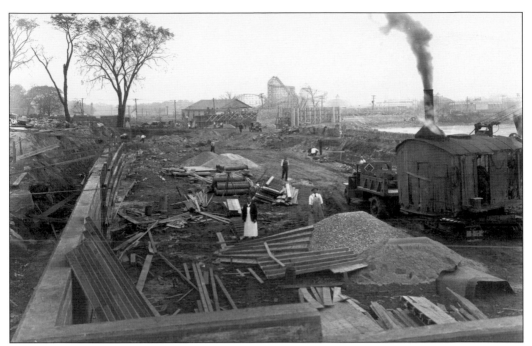

With the old restaurants and bathhouse nothing but a memory, the building can commence on the new bathhouse. The foundation is being laid, and it is a race against time to complete the work for the opening in May 1928. While the bathhouse is being constructed in back of the water area, the amusements continue to progress on the other side of the park.

Merritt, Chapman and Scott Corporation, pictured at right, was hired to fill out the beach area after completing the construction of the breakwaters. The contracted cost for the whole project was $249,200. The dredging boat will have to make many trips out into the Long Island Sound to suck the sand from the bottom to be deposited along the beach and in the swimming area between the breakwaters. Piles of smooth, clean sand can be seen on the boat in the foreground of the photograph.

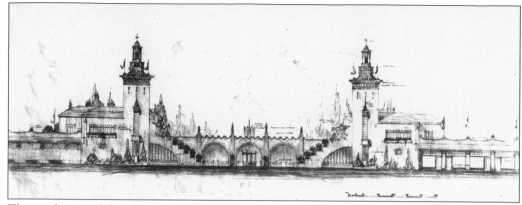

The rendering of the Playland Bathhouse pictured above shows an impressive structure. It will contain locker rooms and changing facilities, as well as restaurants, and an Olympic-sized pool on the side opposite the beach. Colonnades containing shops and food stands will be built in the area to the right on the way back around the boardwalk to the amusement area. The colonnade design will match the colonnades at the entrance to the amusement area and those along the mall.

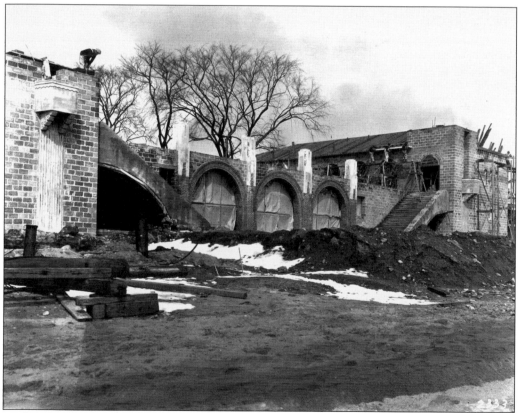

In the photograph above of the bathhouse construction taken in the middle of March 1928, the bathhouse is beginning to take shape. It has a strong, yet interesting, design and is made of fireproof concrete block. Behind the three arches in the center will be the access to the changing facilities. Tunnels from the changing area will give bathers access to the beach to avoid offending patrons on the boardwalk by their lack of dress.

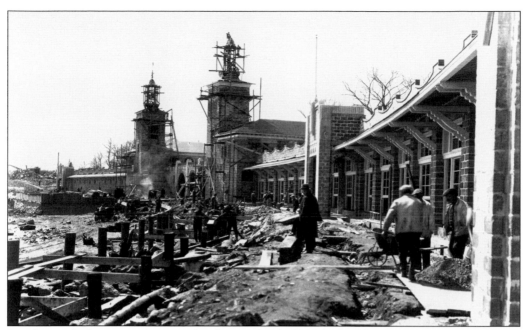

Just five weeks later in a photograph taken in April 1928, the bathhouse is nearing completion. The stucco will be put on top of the brick, giving a light, clean, sun-baked look to the building. Still to be completed is the boardwalk area with the steps leading down to the beach. The beach area will be fenced in. Only bathers will be allowed to use the beach-level food stands.

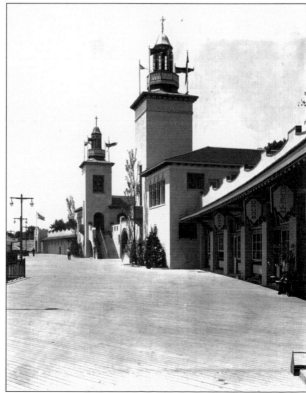

Finally completed, the newly constructed bathhouse waits in the warm sun for the bathers to arrive. New plantings are thriving while the rest of the park is made ready for the summer visitors. Shops extend out from the right side of the bathhouse, with signs for sodas, drugs, and souvenirs. The rooftop restaurant in the center of the photograph offers a wide view of the Long Island Sound for the enjoyment of diners.

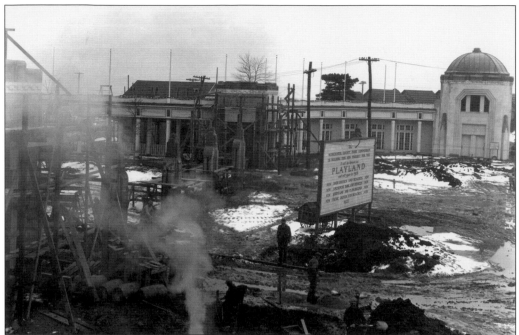

While the bathhouse and beach were being rushed to completion, the amusements on the other side of the park were being completed as well. A sign seen above at one of the grand entrances to the new midway proclaims the coming of Playland Park and all its wonderful features. Workers in this photograph, taken in March 1928, are working fast and furiously to prepare the park for the opening in just two month's time.

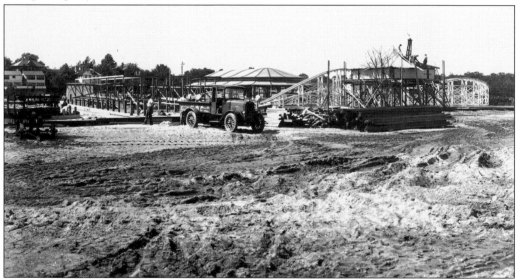

With efforts that began the day after Labor Day 1927, more than 1,000 men with steam shovels, pile drivers, dredges, tractors, and trucks swarmed the whole area. Buildings were begun and completed amazingly in one week's time. In the photograph above, a great deal more work needs to be done. Virtual armies of painters, decorators, electricians, gardeners, and all sorts of craftsmen worked from early morning until late at night to complete the work for inspection by the commission and county officers by May 24, 1928.

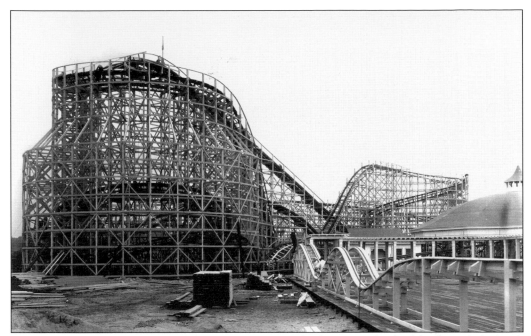

Seen here in contrast to the new Airplane Coaster, the largest individual feature of Playland, is the Kiddy Coaster being constructed in miniature size to the right of the photograph. The Airplane Coaster, designed by Frederick Church, who was brought to the park by Frank Darling to help design and direct the amusements at Playland, is a marvel of a ride that embodies all of the most improved features of safety design.

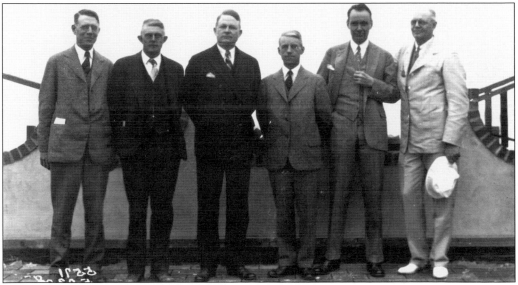

Pictured here the day before the scheduled inspection of the park is a group including Darling, on the right, the driving force and an expert at building amusement parks. The third person from the left is Church. Along with Thomas Prior, his original partner, he designed many roller coasters and the Derby Racer, as well as many other amusement devices. Although officially a resident of Venice, California, Church remained at Playland to design and maintain amusements until his death in May 1936.

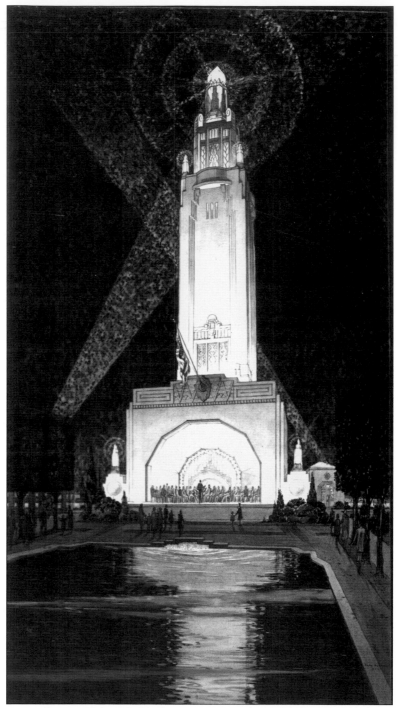

The elaborate rendering of the Playland Music Tower above is somewhat more detailed than what was actually built. While an impressive structure once completed, the music tower never had a water feature in front of it. While it did originally have an orchestra shell, it was not as ornate as the one featured here. It did, however, provide wonderful music and the ability for overall park announcements through many speakers placed around the park.

Two

RIDES AND ATTRACTIONS

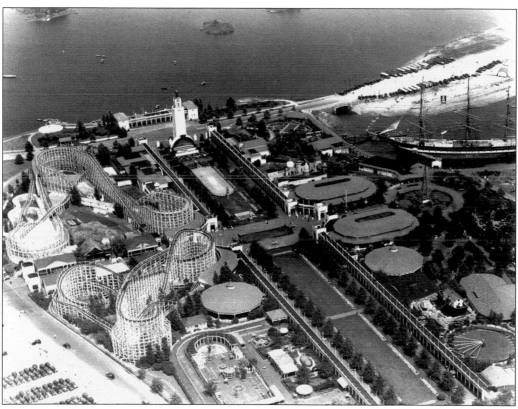

Playland in the early 1930s, as seen in this aerial photograph, was a popular family-fun resort. The midway between the parallel colonnades was often the site to view circus acts or roller-skate on the outdoor rink in front of the music tower. Manursing Island Lake is seen beyond the boathouse, with the Dragon Coaster to the left side, with the Old Mill and the arcade games separating it from the Airplane Coaster. Below that are the Derby Racer and Kiddyland. On the right of the midway are the clipper ship, Bluebeard's Palace, the carousel, and Noah's Ark perched on Mount Ararat.

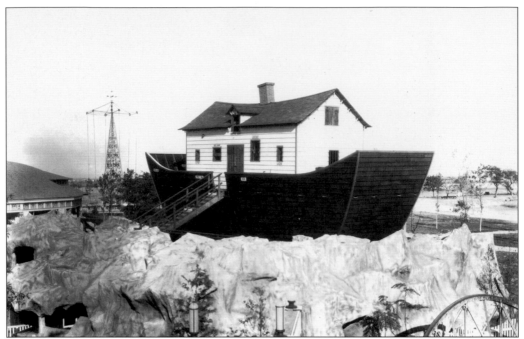

Noah's Ark, pictured here, was one of the original attractions in 1928. It was designed by Leroy Raymond on a patent issued in 1921. The invention simulated a rocking boat. The structure was mounted in a tank filled with water with an engine that moved the boat in a rocking motion as if it were at anchor on the sea.

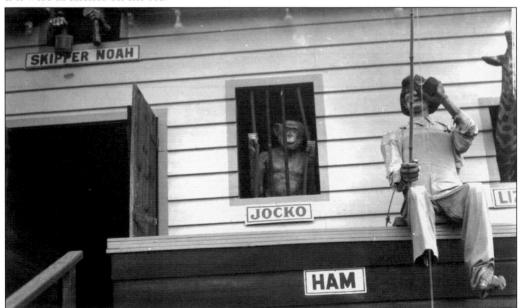

At Noah's Ark, Noah and an assortment of characters and animals greeted visitors upon entry to the vessel. For 15¢, passengers moved along corridors and stairways through a variety of stunts, the whole time feeling as though they were in a ship at sea. Noah's Ark was removed in 1946 and replaced by the Bubble Bounce. Only one Noah's Ark remains in the United States at Kennywood Park outside Pittsburgh.

The new Airplane Swing is shown in motion above the beautifully manicured grounds of Playland. Purchased from J. W. Ely Company for a net cost of $5,805, including an allowance for the old swing ride from the old Rye Beach Amusement Park, the steel gear frame rose 70 feet in the air and held up to 24 passengers. Located near the water, cool breezes could be felt as riders flew in a full circle view of the park for just a dime.

The Whip, designed by Charles Mangels of W. F. Mangels Company of Coney Island, Brooklyn, was installed at Playland in 1928 and is still in use. Free-pivoting joints and centrifugal force generate twists and turns, which change with every rotation. In 1949, twelve new Whip cars were purchased for $300 per car to replace the original ones pictured above.

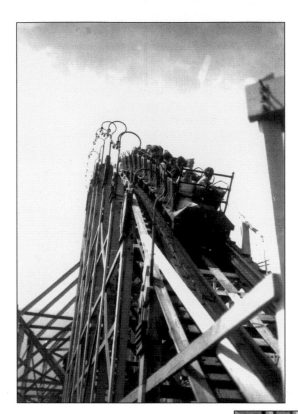

The Airplane Coaster, in use from the opening of the park until its removal in 1951, was named in honor of Charles Lindbergh's flight in 1927. It was one of many designed by Thomas Prior and Frederick Church. In its day, it had been called the greatest wooden roller coaster. The cars traveled at speeds of 100 miles an hour over 3,200 feet of track filled with sharp curves and steep dips.

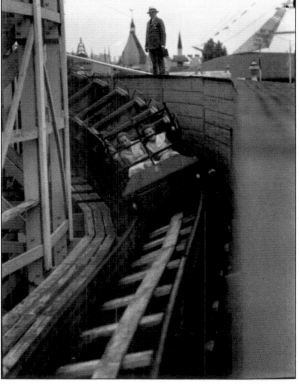

As pictured at right, the Airplane Coaster earned its reputation as the "greatest body wringer and most violent ride ever built." Church devoted his life to designing and improving amusement park rides. He can be seen here standing on the edge of the ride studying the cars as they careen past.

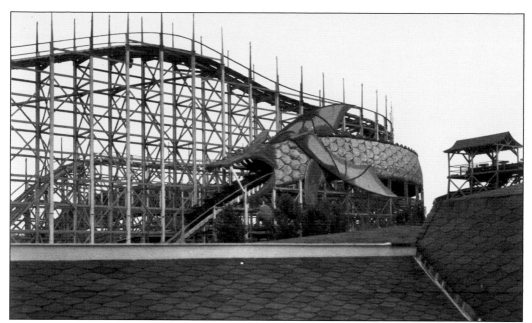

The Dragon Coaster was also designed by Church. Planned as an original ride when the amusement park was designed, it was built in 1929. Riders are given the impression they are being hurled into the mouth of the dragon. As Playland's most famous ride, the dragon has been and remains today, the symbol of Playland Amusement Park.

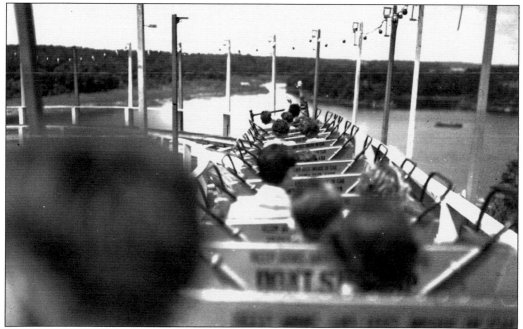

The incredible view from the top of the Dragon Coaster is shown above. After an initial ascent of 85 feet, the ride drops a total of 128.5 feet. It lasts a bit over two minutes. Known as a scenic railroad type of coaster because the cars travel on tracks, the coaster uses inertia to hurl riders back as they careen into the tunnel. The trains have seven cars with two rows in each car, seating from 2 to 28 passengers.

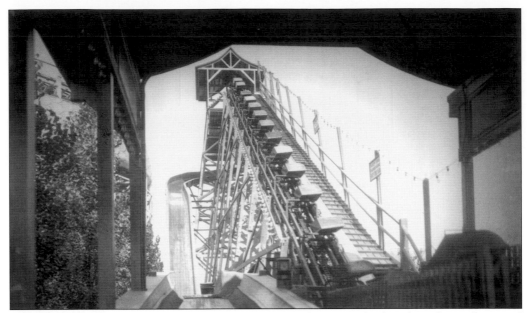

The Jack and Jill ride pictured above was also one of the original rides when the park opened in 1928. Located in the small area on the lake side of the amusements, great views of the park were possible from the 65-foot-high top of the ride. To avoid wasted time, 36 cars, carrying two passengers each, were loaded in continuous succession, making an average of 13 cars each minute reaching the top of the slide.

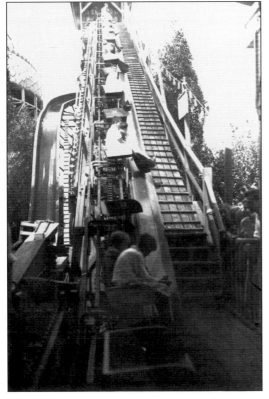

For a 10¢ scrip ticket, riders were carried from the loading station seated sideways in the car to the top of the slide and then dumped into the mouth of a maple-lined chute, which twisted and turned over a total of 185 feet of slide. Riders landed on a cushioned belt, 4 feet wide and 30 feet long. The belt was motor driven to slow the passengers' speed and set them back on their feet eight seconds after the start of their descent.

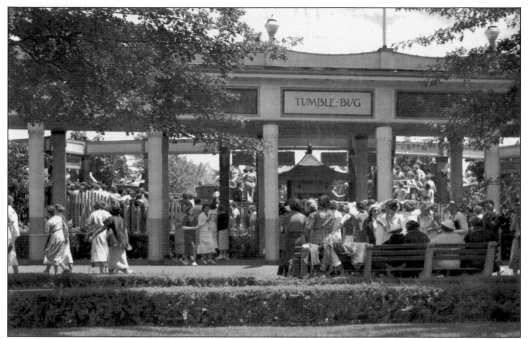

Inviting and clearly visible signs could be seen along the inner face of the top of the colonnade with the names of rides and attractions. Visitors strolling along the inner mall area noticed crowds and read the signs as they determined which ride to experience next. The Tumble Bug was another of the original rides in 1928.

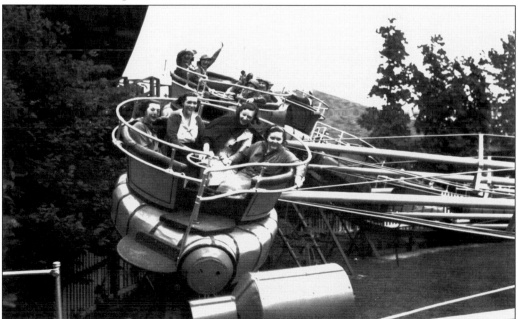

The Tumble Bug, a Harry Traver ride, pictured above, moved in a circle at high rates of speed up and over hills in the track. The five connected saucers all had cushioned seats, which protected riders as their bodies were pushed back into the seat by the centrifugal force. Noah's Ark can be seen in the back left of the photograph.

The Playland Carousel was built originally in 1915 and brought to the park from storage in Connecticut after an extensive search for a special carousel by Frederick Church. It features 66 steeds and three chariots and was originally steam powered. The magnificent horses were carved by Russian immigrant Charles Carmel, who used real horses as models. The classic merry-go-round music was provided by an organ built by the Gaviolis, a famous Italian organ-building family. The mechanical devices were designed by Charles Mangels. The carousel remains a favorite of park visitors to this day.

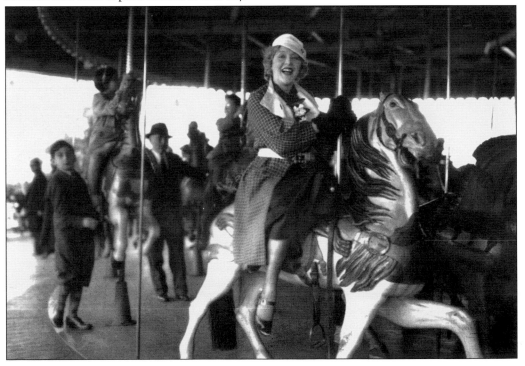

The Derby Racer was designed by Church and Thomas Prior. It was one of the original rides when the park opened and still thrills park visitors today. The ride simulates a steeplechase with a jolting up and down action and special isolating mechanisms that simulate a horse race. The horses travel at speeds of 25 miles per hour. The 56 horses were carved by Charles Illions and finish in a different position on each turn of the ride. The original contract for installation with Prior and Church at a cost of $27,500 included the license for the life of the patent and an agreement to not sell or build another machine of its kind within a five-mile radius of Playland.

Bluebeard's Palace, pictured here, was reported to be a terrifying walk-through attraction. While it had a very attractive and appealing exterior that was visible from almost anywhere in the park, the interior held the secrets of a terrible pirate's lair. It opened in 1928 as one of the original attractions. It was one of the higher-priced attractions at 25¢ a trip.

The *Benjamin F. Packard*, pictured above at its last anchorage, was the last of the wooden square riggers to round Cape Horn. The *Benjamin F. Packard* sailed Cape Horn 52 times, at one point holding the speed record from San Francisco to New York in 83 days. Built in 1883 in Bath, Maine, it sailed until 1924 and came to Playland in 1931. On board, Captain Cutlass and his cut-throats performed daily. Visitors boarding the ship could see the pirate show, an aquarium, and a naval museum, as well as dancing and dining under the stars.

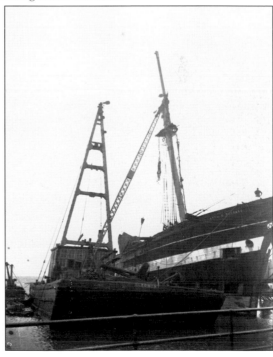

The clipper ship was taken over by Playland when the original owners left with unpaid concession fees in early 1938. It was featured for one more season before a hurricane tore it from its moorings in late 1938, irreparably damaging the ship. The remains were taken apart, as seen in the photograph to the right, towed out to the Long Island Sound, and sunk in about 190 feet of water off Easton's Neck on the north shore of Long Island. The captain's quarters were preserved and are on display at Mystic Seaport Museum in Mystic, Connecticut.

The Old Mill, the interior of which is pictured to the left, was also designed by Frederick Church and was built for the 1929 season. The tunnels of the Old Mill were built under and around the structures of the Dragon Coaster located behind the Old Mill on the lake side of the park.

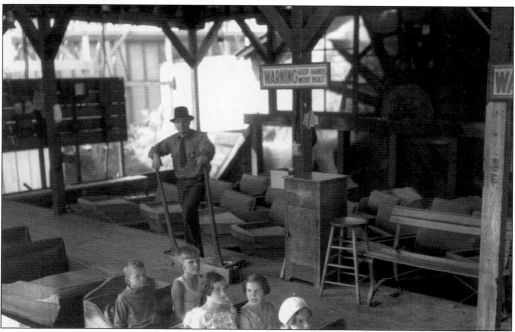

Although enjoyed by all ages, the Old Mill was a dark ride and was often used as a romantic place for couples to snuggle as they floated along in the dark, unaware of the stunts and scenery lurking around the bend. The 1,200-foot ride told a story through the series of stunts that would change periodically over the years.

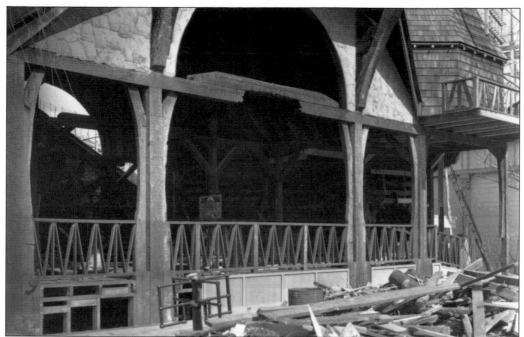

Over the years, the Old Mill was refurbished to update the ride to keep it fun for returning visitors. The photograph above shows some structural and design repairs. Some of the scenes have been a Grand Canyon theme with moveable objects at the front entrance, a western plain scene, a Noah's Ark scene with moving animals and an automatic rain illusion, and a desert with moving objects. The most popular feature was the mule that kicked at people as they passed by at the exit, leaving them in a hilarious mood. The photograph below shows the Old Mill ride in the 1980s. The Old Mill remains a popular park attraction.

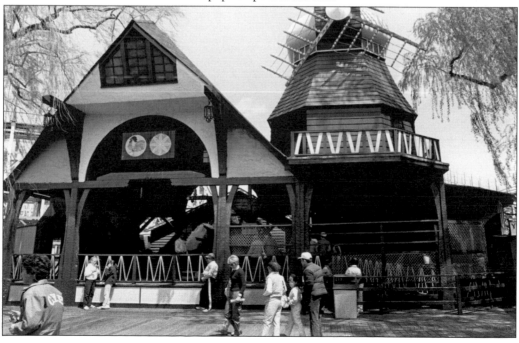

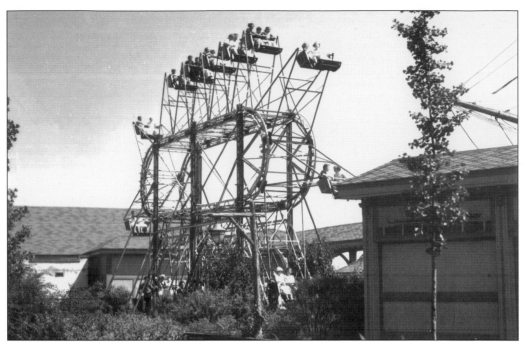

An addition to the park in 1930, the Swooper, one of the more unique rides at Playland, was an oval, Ferris wheel–type ride. Designed by Herbert W. Sellnor in 1929, it was an oval frame on which 15 two-seat tubs were attached to supports. The supports with the tubs were pulled along by cables on a track that traced the outline of the oval. The frame remained stationary. The oval design allowed for the loading and unloading of four tubs at once from the platform alongside.

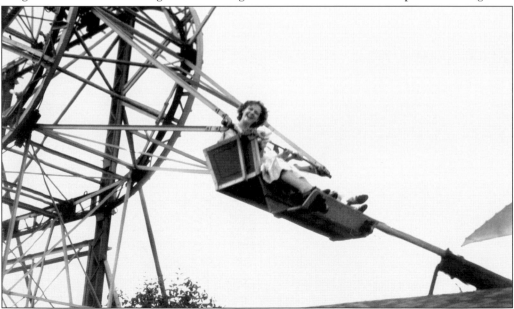

The Swooper's 15 tubs would hold 30 adults or 45 children. With four changes of speed every round, it was advertised as containing "thrills galore." The steel bodies of the tubs seen above were equipped with safety-lock seats. The Swooper was sold in 1939 for $1,400 and replaced by a more conventional Ferris wheel. There are no Swooper rides left anywhere.

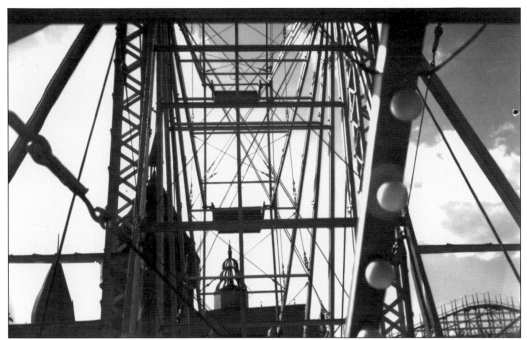

In this unique photograph seen above, the Big Eli Ferris Wheel, provided by the Eli Bridge Company, is viewed from the inside out. Riders enjoyed the comfort of the safety seats as they climbed to the top of the round to appreciate the views of the park and the surrounding area. The Ferris wheel requires comparatively small ground space, making it economical in operation to provide a better payout to the park than other rides.

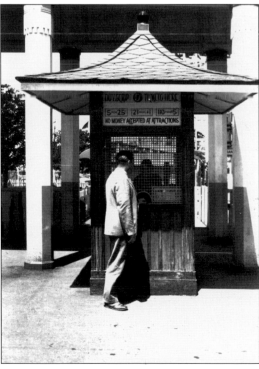

Playland operated on a universal ticket system. Scrip tickets, purchased at booths like the one at right, with a par value of 5¢ each, were good for admission to any ride or attraction. Ticket prices had increasing discounts on a sliding scale depending on the quantity purchased. They were good for the season. Every attraction had a sign giving the price in number of tickets. Recording turnstiles registered the number of patrons, with re-rides counted by old trolley fare registers.

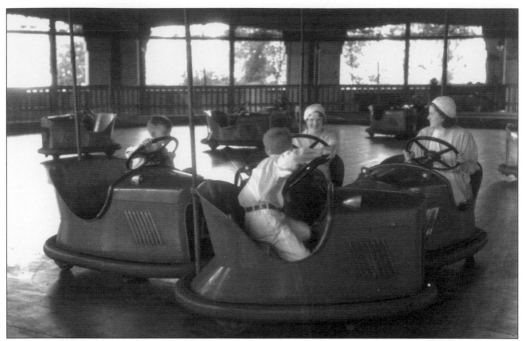

Popular Dodg'em cars, more commonly referred to as bumper cars, were a mainstay at Playland. Models seen here had front-wheel drive, creating a greater degree of flexibility and control. During World War II, rationing of certain materials made it difficult, if not impossible, to get replacement rubber for the bumpers. Ride owners were advised to "nurse bumpers along" by wrapping worn or cut sections with canvas strips.

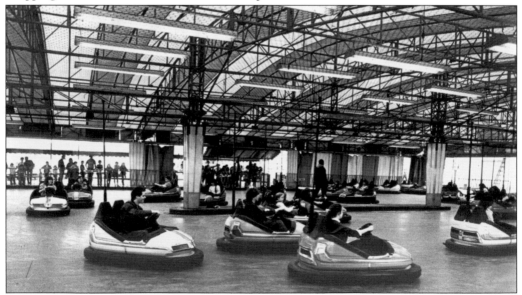

This 1980s photograph of the newer bumper cars contrasts the modern cars with those of the past. Newer cars are built with considerably more padding to protect drivers and their passengers from the jolting by other cars. Over 50 two-person cars provided drivers with the opportunity to drive recklessly, while experiencing the satisfaction of bumping other cars out of the way as their cars raced around the track.

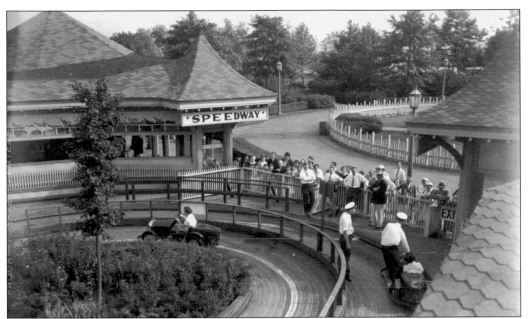

The Motor Speedway was introduced at the Century of Progress Exposition at the world's fair in Chicago. The cars, although designed primarily for children, can accommodate an adult driver and have balloon tires, lights, horns, bumpers, and spare tires. Due to a lack of muffler, they make as much noise as possible as they race around the track. Gasoline rationing during World War II shut the ride down for three years.

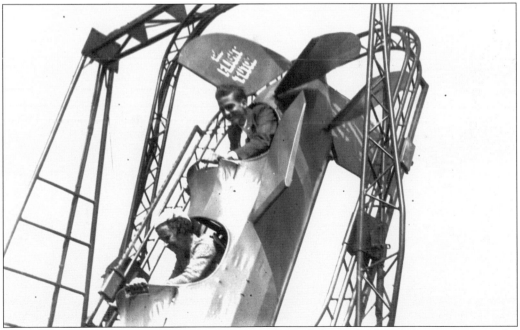

The American public's continued fascination with air flight made the Flight Tutor a popular ride. Two Flight Tutors operated at Playland from 1933 to 1938. The ride provided a unique opportunity for the average person to fantasize about piloting an airplane without the inherent dangers of taking off into the sky.

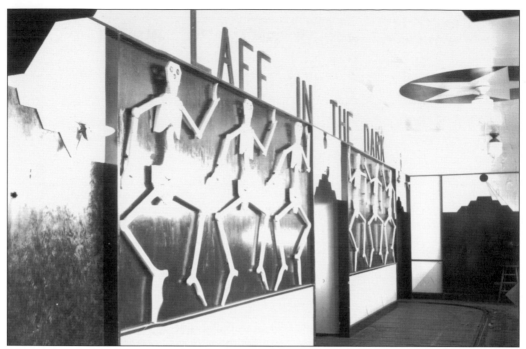

The Laff in the Dark was introduced to Playland in 1934 by Harry Traver. A dark ride, it was advertised as the funniest ride ever built. Patrons laughed and screamed so loud they could be heard outside in front of the building. They all came out of the ride smiling.

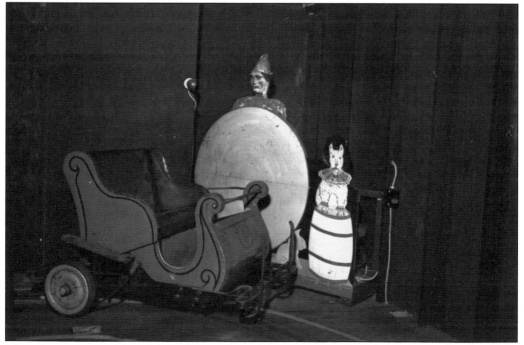

The tilting seat feature seen clearly in the photograph above was patented by Harry Traver and could only be used on the Laff in the Dark ride. It was said to be the best stunt of all, as it introduced the element of surprise, causing many a laugh and scream from the patrons.

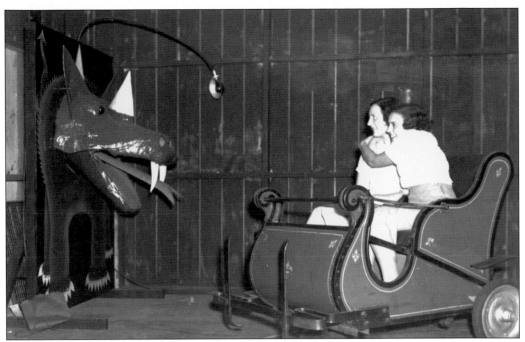

Looking at these two photographs, one sees the side view above and also the view of what the rider encounters head on in the photograph below. The dragon opens his mouth, tripped by a switch as the car moved along the tracks. The light hanging out in front of the dragon flashes on its mouth as the mouth opens, creating a very scary effect as the car comes close to the danger before quickly turning away and moving on to the next stunt.

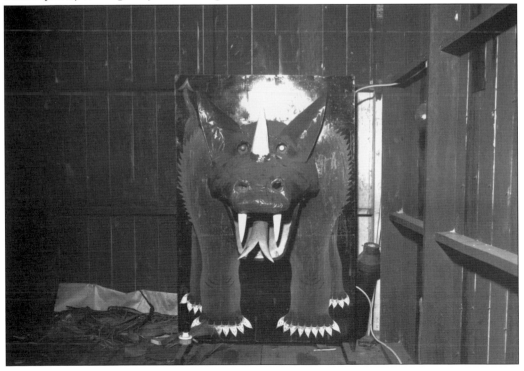

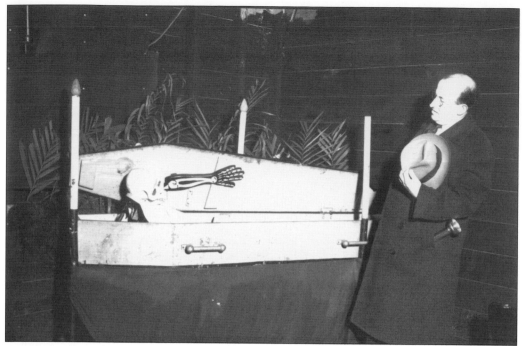

As riders roll in their specially designed car toward the stunt seen above, the coffin opens and the skeleton groans as it creaks up from its resting place. The car with the startled riders comes perilously close to the frightening sight before rolling on to the next surprise.

As with many amusement rides, the interior stunts were changed from season to season to keep riders coming back. In 1937, Mr. Strobel, manufacturer of Strobelite, made dark rides even more exciting. The Strobelite, with ultraviolet lightbulbs combined with the new fluorescent paint, created even better effects as the cars traveled along.

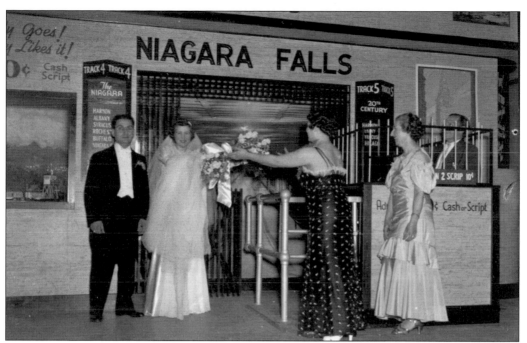

One of the more unique attractions at Playland was Niagara Falls, Scenic Wonder of the World. Over-the-Falls was a walk-through attraction that simulated a train station beginning to a panoramic experience of Niagara Falls providing some folks, like those in the photograph above, the opportunity to get married at Niagara Falls for the cost of a 10¢ admission. Installed by Fred Fansher, delivery and set-up of the secondhand exhibit with complete equipment was $3,200. Panoramas (like the one pictured below) were intended to give visitors the feeling of being at the mighty Niagara Falls.

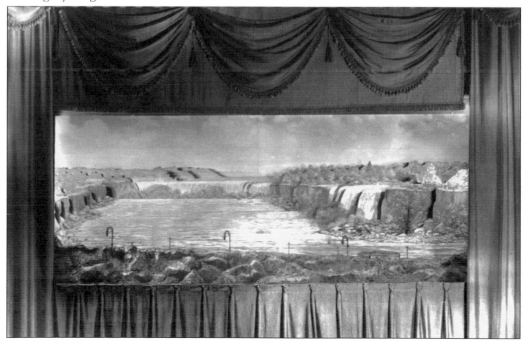

Jungles, a walk-through attraction, opened on Easter Sunday in 1931. Ernest Anderson designed and built this in his own house, and his wife fitted the hides over the molded frames he made. Mrs. Anderson's father constructed the mechanical-electrical movements for the somewhat lifelike jungle animals that were set in appropriate settings. Advertised as realistic thrills from darkest Africa, it was described as a trip to primitive Congo that quickens the pulse.

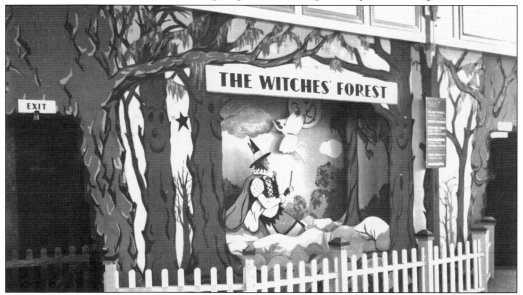

Fred Fansher provided Playland with many walk-through attractions over the years. The Witches' Forest pictured above was built for the 1935 season. It was designed and built by Bill Larkin. Walk-through attractions were popular with patrons due to the changing of the stunts from season to season. Many had fun house–type aspects that surprised visitors and alternately scared or amused them.

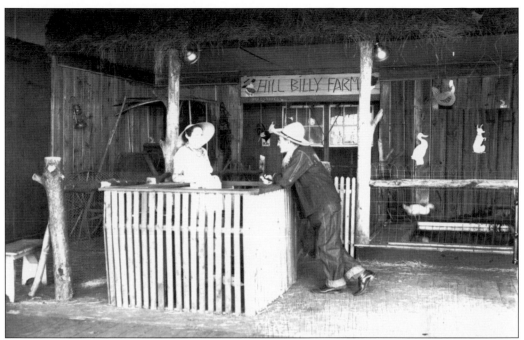

The Hill Billy Farm, pictured above, was another attraction built by Fred Fansher in 1936, and Bamboo Fun, pictured at right, followed in 1937 as another walk-through attraction. Walk-through attractions were very popular with concessionaires and amusement parks since patrons were self-sufficient, needing very few paid operators, particularly in a time when the Great Depression was limiting funds available from profit. Novel lighting effects, combined with a number of unique stunts, would keep patrons coming back for more fun and excitement.

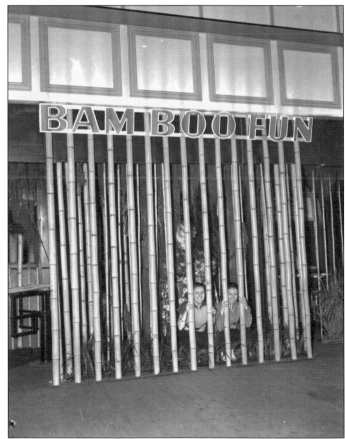

The fun house, or Magic Carpet as it was officially known, opened for the 1937 season in the building vacated by the circus, which was no longer as popular as it had been. It was a concession of Harry C. Baker of Park Beach Supply Company, responsible for many attractions at Playland over the years. As the sign at the entrance advertised, it was a place designed for the amusement of all kids age 3–99. The entire interior of the attraction can be seen in the photograph above.

The most popular components of the fun house can be seen in the photograph above. The more-than-two-story slide is accessed by stairs alongside the carpeted slide on rollers. The attraction had a Moorish theme, and although popular with patrons, was a problem for concessionaires due to the fact that visitors moved around under their own power. They were able to stay in the fun house for as long as they wanted, thus limiting money spent on other rides at the park.

Underneath the lower portion of the giant slide was the horizontal revolving cylinder that patrons tried their best to walk through. The interior view of the revolving cylinder can be seen in the photograph above. Once patrons lost their balance and fell, they made it that much more difficult for others to stay standing, which created a hilarious pile of people.

The large spinning floor disk with the elevated center, seen in the photograph above, uses centrifugal force to throw patrons out to the edges of the disk against the padded ring. Other amusements in the fun house, such as movable floors, were provided by mechanical devices meant to make participants feel as though they were going through a bizarre obstacle course. Fun house mirrors distorting images of patrons added to the hilarity.

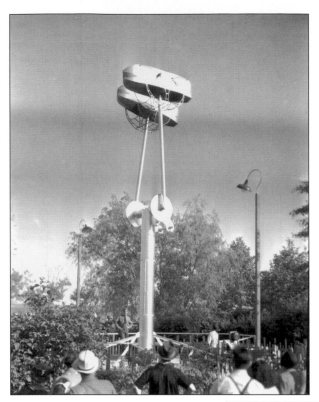

The Loop-o-Plane, "King of the Midway," as seen in the photograph to the left, was provided by concessionaire Everett G. White of Pelham, New York, in 1936. The Loop-o-Plane operated for many years and was advertised as giving the sensation of a simulated 40-foot fall. It was like the looping of an airplane yet smooth. It did not rough up or shake up passengers.

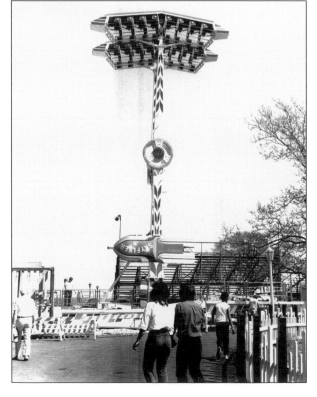

In contrast to the old Loop-o-Plane is the Sky Flyer, seen to the right in this photograph from the 1980s, a modern version popular in the later years of the park. Once strapped carefully into this vehicle, riders experience the back and forth pendulum motion as the Sky Flyer reaches its highest point and begins flying in a circle.

Three

KIDDYLAND

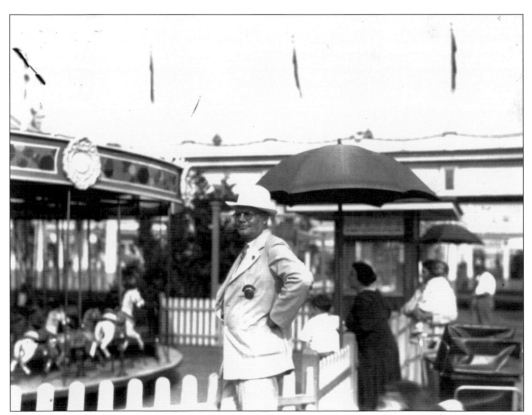

Kiddyland was designed as "an amusement park in miniature to fit small hands and short legs." A prediction in a local paper, prior to the park's opening in 1928, correctly forecasted that Kiddyland, the "pet" of Frank Darling, seen standing here in the middle of Kiddyland, would be the most popular feature of Playland. Darling was often seen around the park in his signature white suit and hat. He took great pride in Playland.

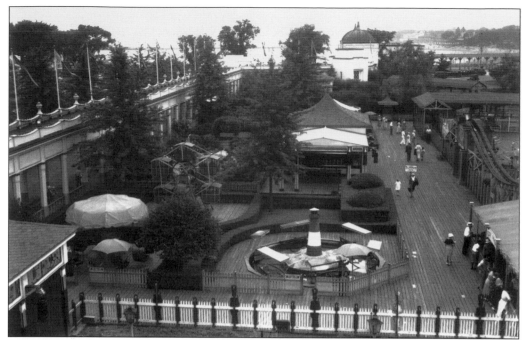

In a low aerial view here, the pony track is located at the bottom of the photograph with several kiddy rides visible, as one looks toward the beach and boardwalk area at the top of the photograph. The Kiddy Coaster encircles the playground while the colonnade to the left separates Kiddyland from the mall and the rest of the amusements.

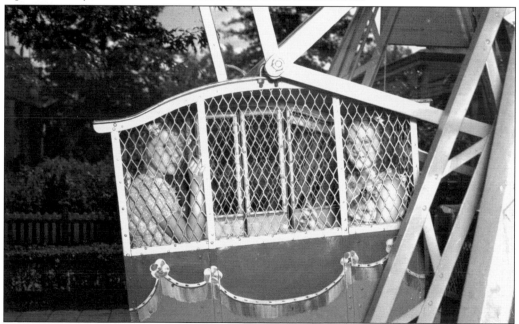

The little girls enjoying the Kiddy Ferris Wheel are safe within their bucket. The totally enclosed space alleviates concerns about children's safety as the bucket rolls up and over the top of the wheel. Seen also in the photograph at the top of the page, the Kiddy Ferris Wheel is a six-bucket ride that rises just high enough to excite young children.

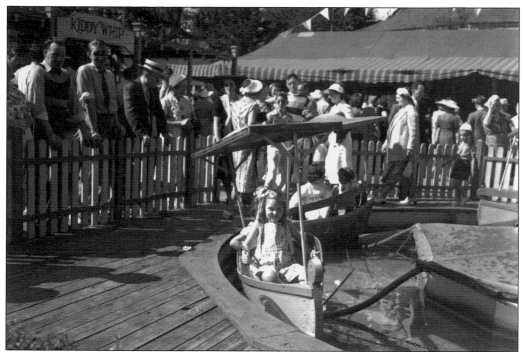

The Kiddy Boat Ride above, seen also in the view of Kiddyland on the facing page, was designed to float in a low water tank, enabling the feel of boats riding on the water while maintaining a safe environment for little patrons. Canopies protected little heads from the hot sun of a summer's day. A similar boat ride in Kiddyland in later years can be seen in the image below. The newer boat has the additions of steering wheels for young hands and a bell to ring and is adorned with an American flag.

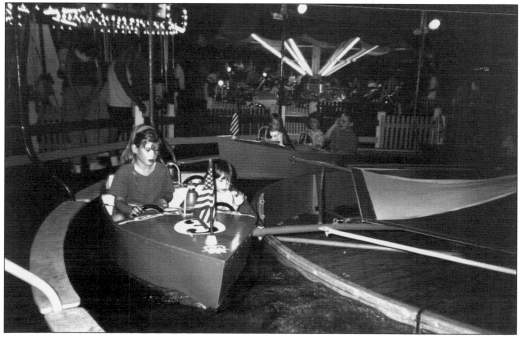

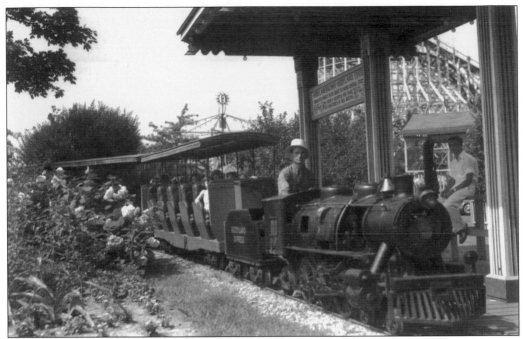

The Kiddyland Express was a favorite of children and adults. It was a ride for the whole family, providing an exciting scenic railroad train ride around Kiddyland for children and a few minutes of relaxation for adults. The Playland train, as with most amusement park trains, was gasoline powered, eliminating the need for an official union train engineer.

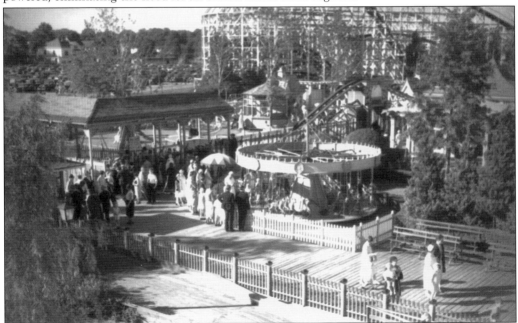

Nestled in the shadow of the Airplane Coaster, Kiddyland was an exciting place for young children. The carousel in the center of the picture, designed by W. F. Mangels, was made to last. The Motor Speedway is in the foreground with the Kiddy Playground at the top left in the photograph. To bring shade to Kiddyland, 12 large American elm trees were planted.

Cast aluminum horses were used in the original design when building the Kiddy Carousel to take the wear and tear of children. An early close-up photograph of a young girl enjoying a ride on the carousel shows the excellent yet whimsical workmanship of the miniature horse design. A close-up of a young girl on the same horses more than 60 years later confirms the success of the origin design choice.

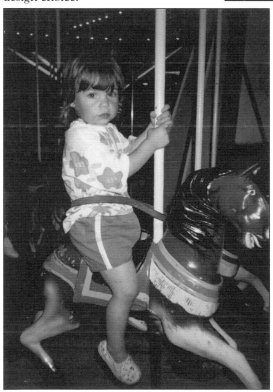

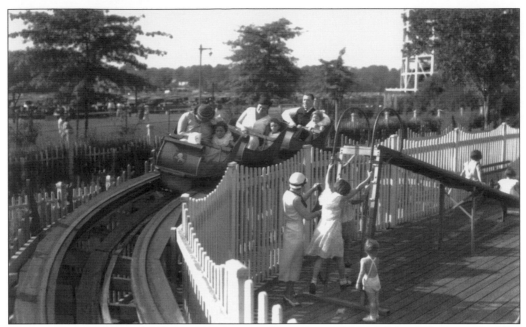

The miniature Kiddyland roller coaster was a smaller version of the adult's popular wooden roller coaster. Designed by Frank Darling, it was built by R. S. Uzzell for $2,537.50. With enough thrills for adventurous youngsters, the coaster wraps around the Kiddyland Playground, enclosing youngsters in a safe, carefree play area. While built for children, seats were also large enough to accommodate parents wanting to accompany their children. The original coaster cars were replaced in 1953 after 25 years of service.

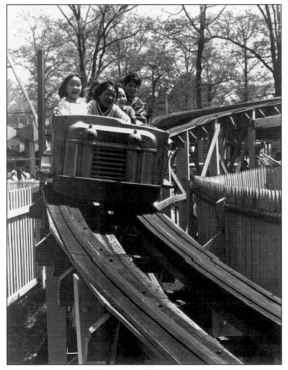

Obviously built to last, the original framework and tracks of the Kiddyland roller coaster can be seen here in a photograph from the 1980s. Judging from the looks on the faces of the children in the newer coaster cars, the roller coaster remains as thrilling to young riders as it was originally.

1936

COMPLIMENTARY INVITATION FOR

KIDDYLAND

PLAYLAND

Westchester County Park System

RYE, N. Y.

FOR SCHOOL CHILDREN 13 YEARS OF AGE OR UNDER

This Ticket good any day except Sundays and Holidays
from the Season's Opening to June 15th

— May 16 —

As many as 250,000 complimentary Kiddyland ride tickets, like the one pictured above, were distributed every year to pupils attending kindergarten through the elementary grades in Westchester County schools. The tickets were offered for use in June to encourage patronage at the start of the summer season. The practice of distributing tickets, while not done every year, was a regular practice for many years.

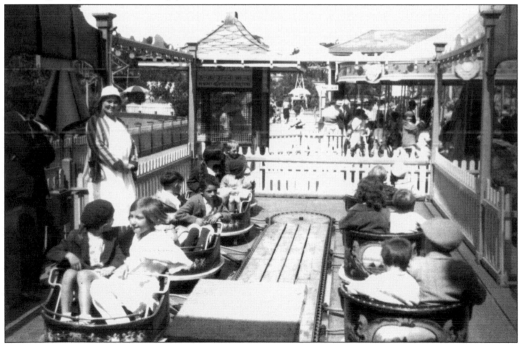

The Kiddy Whip pictured here was another miniature of a favorite adult ride. It was very much smaller than and not anywhere near as fast as the larger model, but young children were nevertheless very excited by the relatively quick movements of the revolving cars. The Kiddy Whip remained popular in Kiddyland for many years.

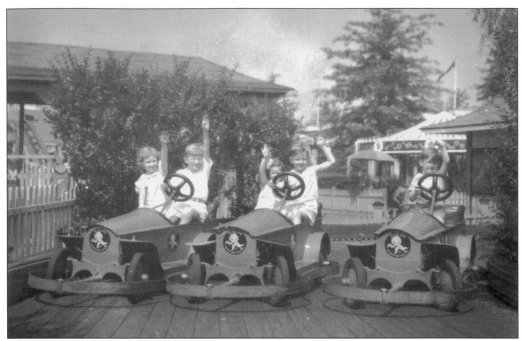

The Midget Roadster pictured here, while designed for young children, was also capable of carrying small adults. This very popular miniature gasoline-propelled automobile was safe and fun to drive and relatively cheap for the park to operate. The optional side bumpers added additional safety for the inexperienced young driver.

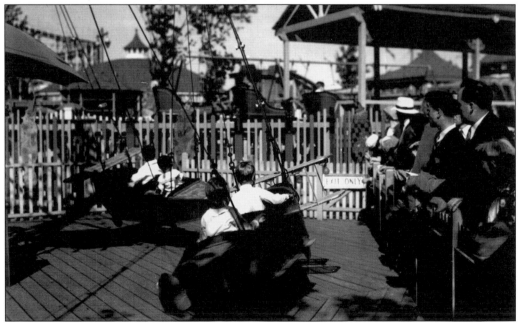

The Junior Fly-A-Plane, pictured above, was designed for children up to 12 years of age. It was advertised as the nearest thing to actually flying a plane for budding young aviation enthusiasts. Parents look on as their children take flight. A miniature of the adult's Airplane Swing, it was designed to carry six to eight passengers.

While some of the old rides such as the carousel and roller coaster are still available in Kiddyland, with entertaining the young child the intent, kiddy rides have come and gone over the years. Newer automobile rides, helicopters, floating swans, and Mack truck trains keep children happy as parents and grandparents look on.

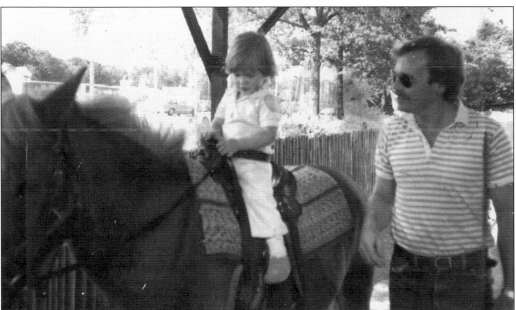

Pony rides, although not available continuously throughout the park's operation, have always been a favorite of children. Ponies need much more care than mechanical rides, and stabling facilities were not always available. Concessionaires would have to transport ponies back and forth to work at Playland, to the joyous delight of young equestrians like the young girl pictured here in the park's later years.

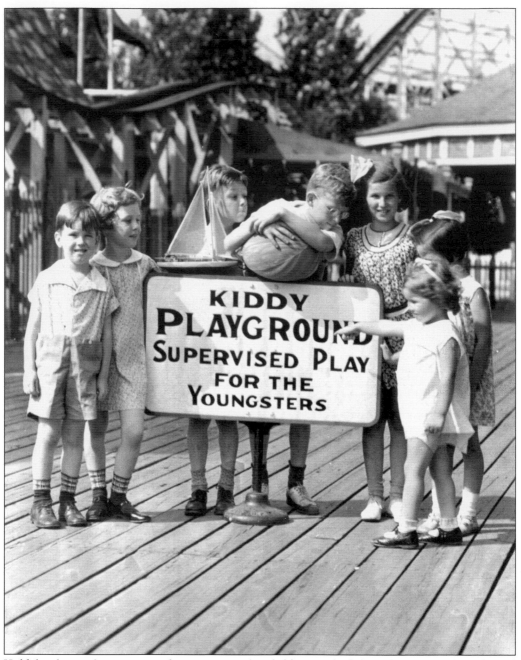

Kiddyland was the most popular attraction for children and adults. The motto of Kiddyland playground was "park 'em and forget 'em." Kiddyland provided safe, fun entertainment for youngsters with a miniature roller coaster, swings, slides, merry-go-round, wading pool, miniature train, and much more. Children played in the shade of 12 oak trees planted especially to add to their comfort on the hot summer days. What could be a better place to play?

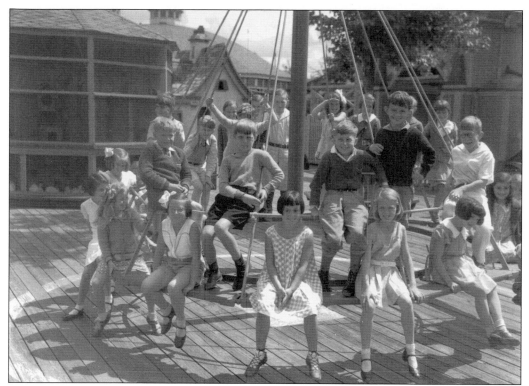

Nurses were hired to watch children to ensure they were safe as they played. Parents were free to leave their children under their safe watch while they went off to other amusements, the restaurants, the beach, or other activities. The large circular swing above was always crowded with children. The teeter-totters below were also a favorite part of the playground. There was always something fun to occupy a child's time and always other children with whom to play.

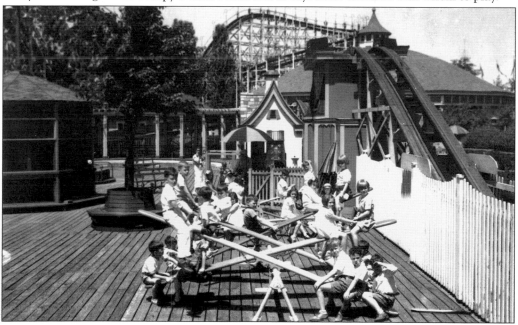

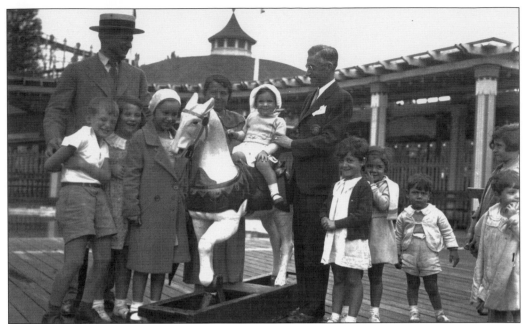

Herbert O'Malley, in the center of the photograph above, was the second director of Playland. He is seen here in the Kiddy Playground with some of the young patrons of the park. The rocking horse was a fair substitute for the real thing, although a lift up would be needed to reach the saddle on this rather tall rocking horse.

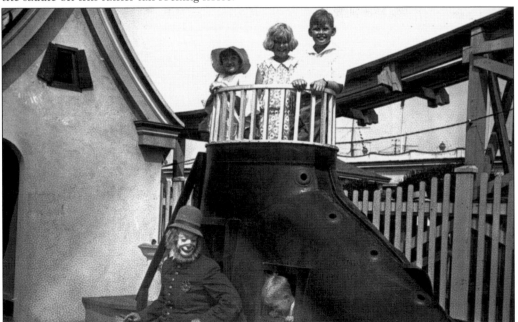

"Keystone Kops," like the one in the above photograph, entertained Playland visitors from the earliest days. The big shoe full of children was used during the opening ceremonies in May 1928. Ada E. Perkinson of Rye, known as "Mother Westchester," and 36 small girls from the Milton School represented various Westchester communities. The group started the official inspection of the park while riding around in the large, motor-propelled shoe.

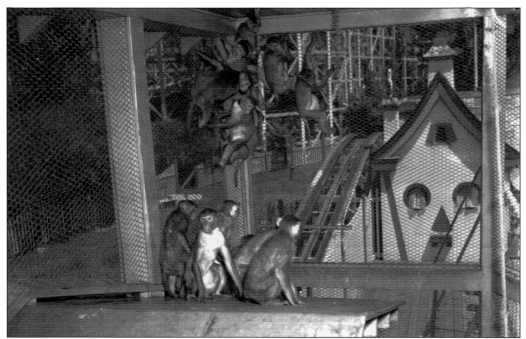

A barrel of monkeys is always a lot of fun. The monkeys pictured above lived in a circular cage in the Kiddy Playground section of Kiddyland. They are seen climbing all over each other in the photograph above, and the cage can also be seen in the photograph below. Children could take a break from their play and watch the monkeys at play. The view of the Kiddy Playground below illustrates how clean and inviting the grounds were, even with no children around. Small benches with umbrellas provide resting places out of the sun. The elm trees continue to grow and will, within a few years, provide shade to the whole area.

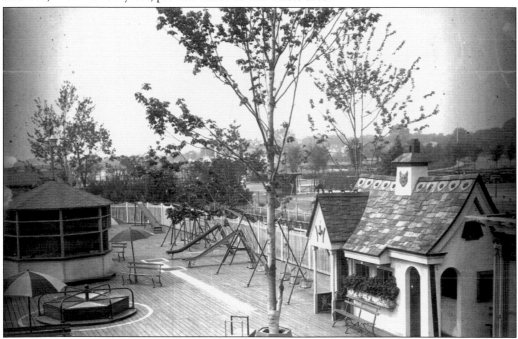

The young girl pictured above is content to play with a doll in the charming little house specifically designed for small children with big imaginations. The exterior of the playhouse can be seen in the photograph on the previous page. The house, though not used for play, still remains as a decorative reminder on the grounds of Kiddyland.

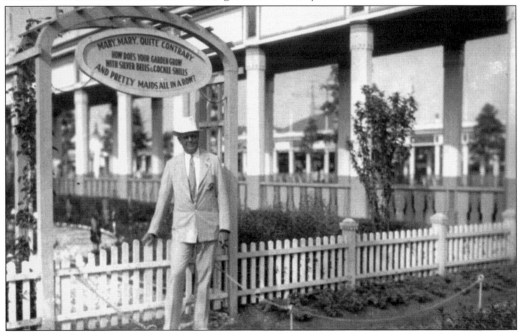

The "Mary, Mary Quite Contrary" garden, pictured here behind director Frank Darling, is an almost exact replica of the garden in the children's verse. With silver bells and cockle shells all in a row, it is just one of the many beautiful planting areas around the park. Children and adults can feel free to walk among the beautiful flowers that are continually maintained.

Four

ENTERTAINERS

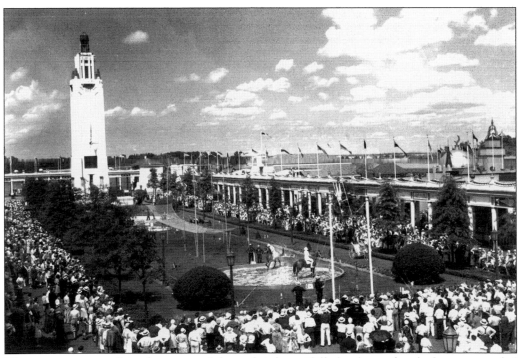

The open, grassy mall in the center of the park is beautifully landscaped and often surrounded by spectators as they watch a variety of attractions and performers. The grand music tower at the far end of the mall was equipped with the latest radio machines to provide restrained, harmonious music that was diffused throughout the park at all times. Circus acts spread out along the length of the mall provide entertainment for viewing at every location.

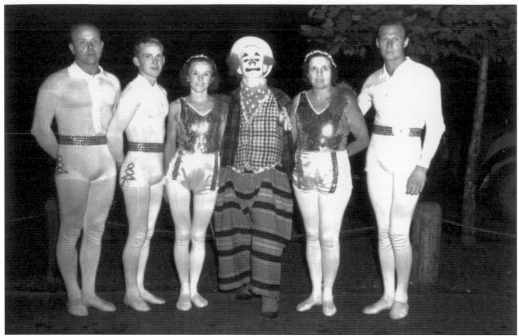

The family of Fearless Flyers, pictured as a group above and in action below, were just one of the many circus acts that performed at Playland over the years. Wearing the requisite leotard of the flying trapeze artist, they perform high above the crowds. Performing twice daily, once at 3:00 p.m. and again each evening at 8:30, they gave the crowd an outstanding exhibition of skill and daring. To encourage attendance at their show, performances were preceded by a parade through Playland.

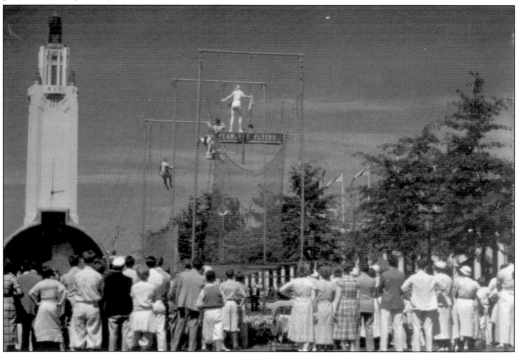

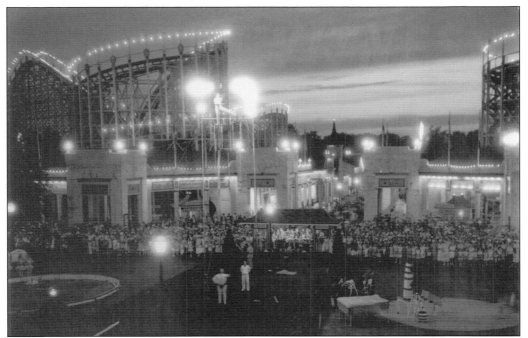

Nighttime at Playland was magical. Seen here in the lights of the midway, a performer spins around at the top of a pole in the center of the photograph. The amazed audience watches the performance as the heat of the day is relieved by the cool breezes coming in from the water. All areas of the park were well lit to extend the time for bathing, picnicking, and enjoying all that the park had to offer in the way of entertainment.

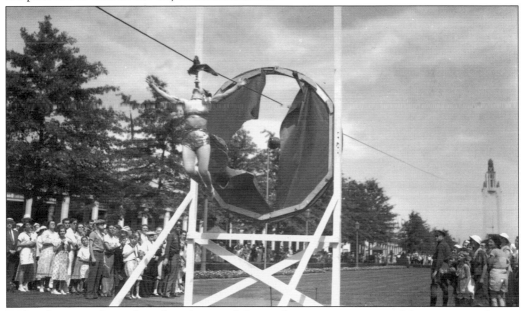

Before the amazed crowds gathered to watch her performance, a young and daring woman began her descent from the top of the music tower, sliding across a wire hanging by a strap as she breaks through the screen before completing her descent. The entire length of her act is done professionally and with graceful movements.

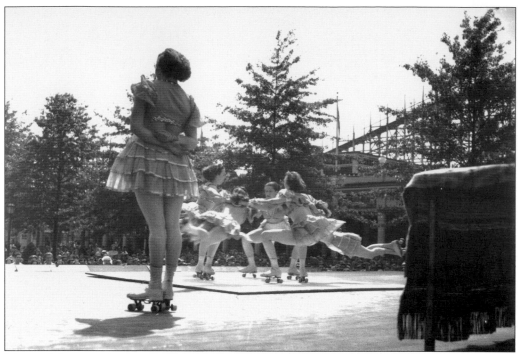

Many of the special acts performed right on the stage in front of the music tower. The lovely roller-skating ladies pictured above were not just fun to watch but an inspiration to all roller skaters who enjoyed spending time roller-skating on the rink that was in front of the music tower in the early years of the park or in the casino during the summer months when roller-skating was offered. Pictured below is Kula and one of her elephants. Also a part of the circus, the pachyderm seen here was a special treat for Playland audiences. Visitors to Playland often planned their trips to the park around the entertainment scheduled.

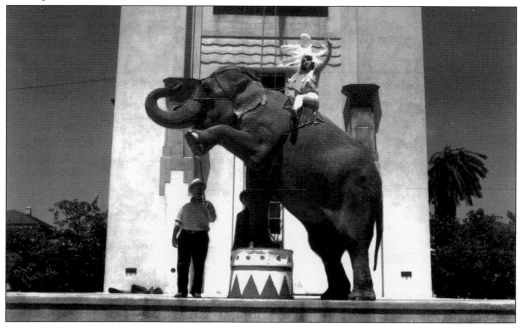

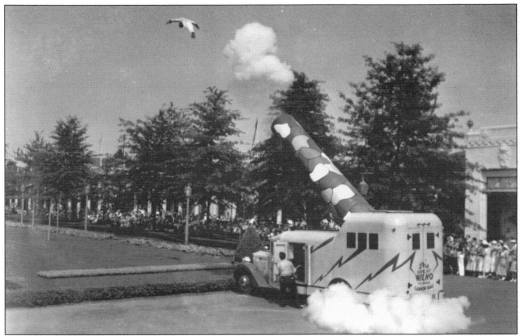

The Great Wilno, Human Cannonball, can be seen flying through the air over the midway to land in the net, seen to the left in the photograph. Of the 50 recorded human cannonballs in the last century, 30 were severely injured or killed when they miscalculated and missed the net, landing on the hard ground in front of spectators. W. W. Wilno survived his career as a human cannonball, exciting many before retiring to the town of Peru, Indiana. Wilno was inducted into the Circus Hall of Fame in 1991.

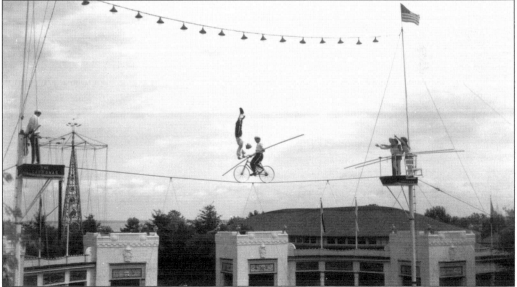

The Gretonas, pictured above on the high wire, balancing on poles across bicycles, appeared to be more fearless than the Fearless Flyers. The Gretonas performed high above the crowd without any evidence of a net. A variety of high-wire and trapeze acts were presented each season. Many returned year after year to perform for the Playland crowds.

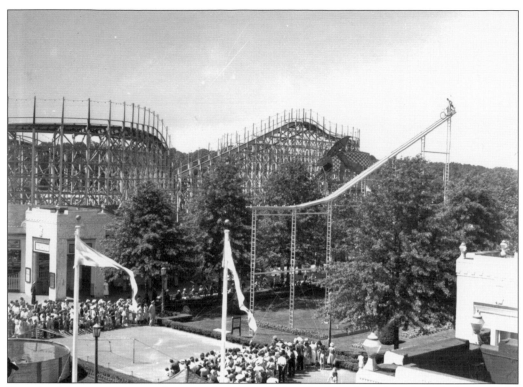

Seen in these two amazing photographs is a special performer who rides a bicycle down a very long ramp and then shoots up into the air. The photograph above shows the daring performer at the top of the ramp. The photograph below shows him after he is airborne and becomes separated from the bicycle. As he floats through the air toward the small pool of water, the crowd holds its collective breath, hoping he meets a safe end.

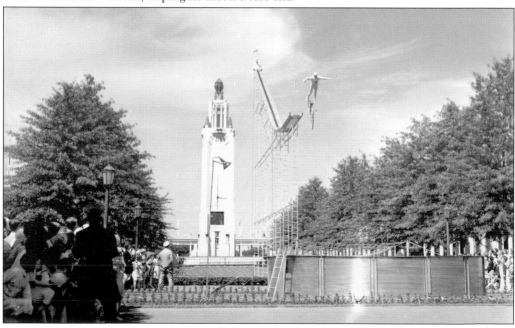

Another daredevil, pictured at right, rides a bicycle down from the music tower and then up through a circular ramp. The performer can be seen as he comes around and down through the circular ramp. As he exits the ramp, he lands on the platform in front. Looking back up the ramp, a man can be seen walking down the height of the ramp, checking for problems. Lightbulbs line the sides of the ramp to illuminate the ride for the nighttime show. Many a modern skateboarder would love the challenge of this ramp.

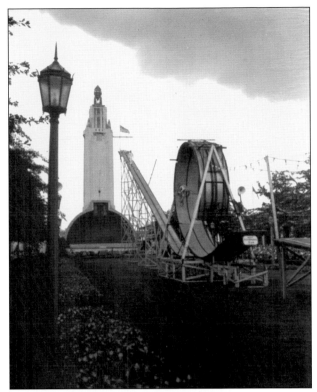

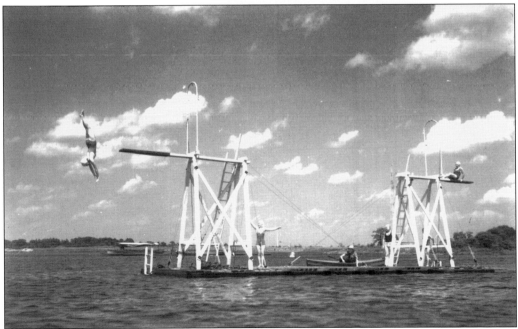

Performing for the crowds on the beach are Inez Wood and her bevy of girl divers. Wood held a number of amateur championships prior to turning professional. The divers were just a part of the Water Circus that commenced daily at 3:00 p.m. The gigantic water carnival consisted of clowns, trapeze performers, high-and-fancy divers, and other aquatic performers.

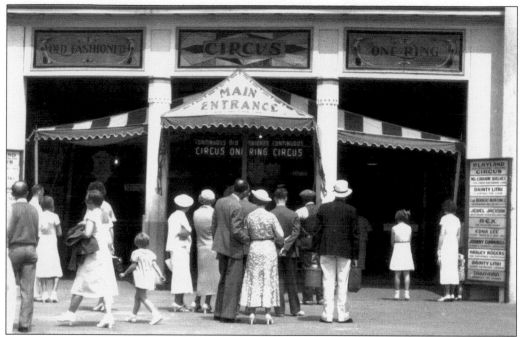

The circus began performing under its own roof in the early years of the park, until it waned in popularity and was replaced by the fun house in 1937. Many performers were enjoyed over the years, most of them booked by George A. Hamid, Inc., General Amusements of 10 Rockefeller Plaza, at Radio City. Hamid worked with the directors of Playland to provide popular and exciting acts for patrons of the park.

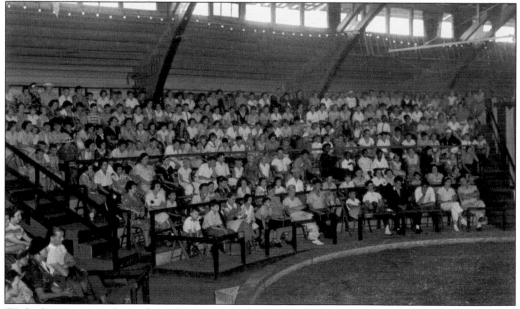

With the sign outside reading, "Playland Old Fashioned Circus," the crowds packed the circus arena located across the mall from the Airplane Coaster. The outer ring of the circus can be seen at the bottom of the stands as the excited crowds await the next act. Will it be an animal act or a daring feat?

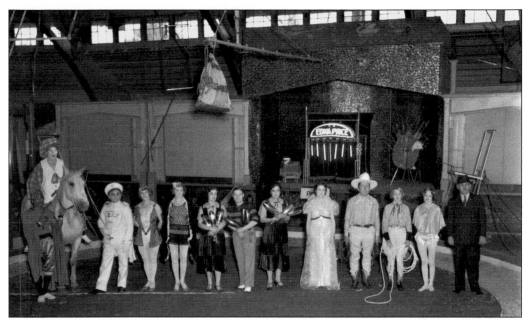

The lineup of Hamid's circus is pictured above. Hamid is on the far right. The fifth entertainer from the right is Edna Price, also seen performing below. Other performers include Johnny Cummings, a clown and comedy juggler, on the left; Mlle. Lorraine Wallace, with performing lions third from the right; and Edna Lee, flying trapeze, second from the right.

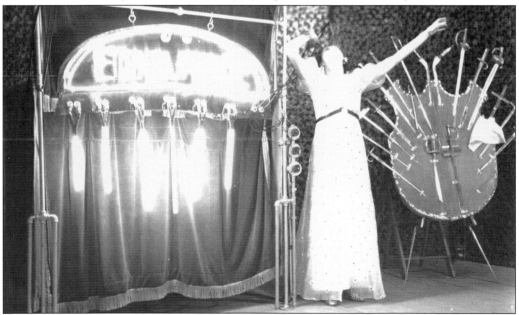

Sword swallower Price was a hit attraction at Playland. Price would swallow up to 12 swords at once and then remove them one by one. She learned her craft from her Uncle Delno Fritz, master sword swallower. A member of the Sword Swallower's Hall of Fame, Price gained entrance into the Guinness Book of World Records for being the first woman to swallow neon tubes. Price performed at the 1933 world's fair. She had her swords chromed every year to protect against nicks and scratches. After sword swallowing for 20 years, she quit in 1940.

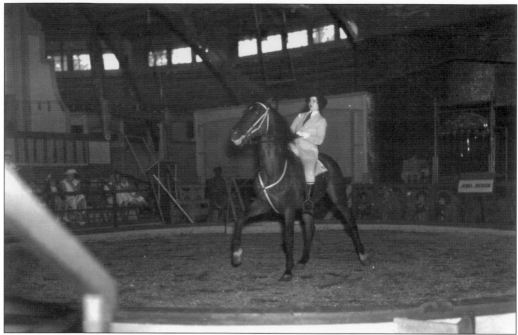

Animal acts were favorites of the Playland audience. Jewel Jackson, equestrian, is pictured here prancing around the ring on her performing horse. Performing in the one ring, the circus acts had to work to keep the attention of their audience. Around the perimeter of the building were sideshow acts designed to grab the attention of all. Wallace and her big performing cats kept the audience on the edge of their seats. Wild cat performances were popular with audiences, but performers had to watch themselves and be careful to remember their charges were wild animals. Too often "trainers" were mauled or killed by the animals they trained while the horrified audience watched.

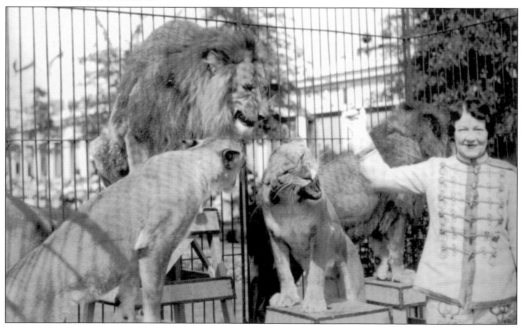

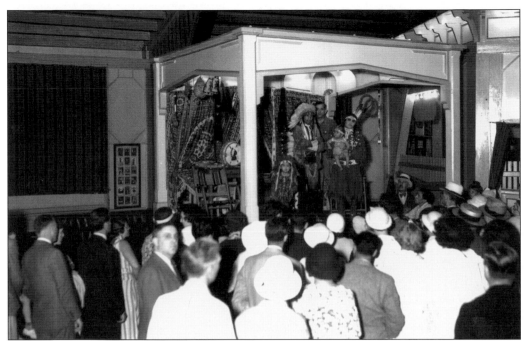

Two popular sideshow acts are pictured here. The "Indians" on display here were of particular interest to New York area residents. Milo Billingsley had the Indian Show Concession brought to Playland for the pleasure of crowds that had never seen a Native American. Native dress and other Native American possessions were on display. Below is another nonindigenous attraction. Alligators were not something that New Yorkers were likely to have ever seen. Even the small one pictured below was an attraction. No one seems to mind that the alligator has been removed from its natural habitat for the enjoyment of audiences.

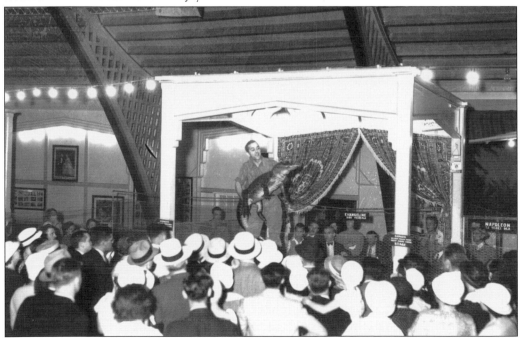

An amazing feat of levitation is being performed here by this Asian act. With no strings visible, audiences stood mesmerized by the awesome execution of the levitation. In the photograph below, the skinless man is on display. Although it would seem too impossible to be true, people crowd to the front to get a glimpse. Others can be seen searching the arena for more incredible things on display. And all this could be experienced for a 15¢ scrip ticket.

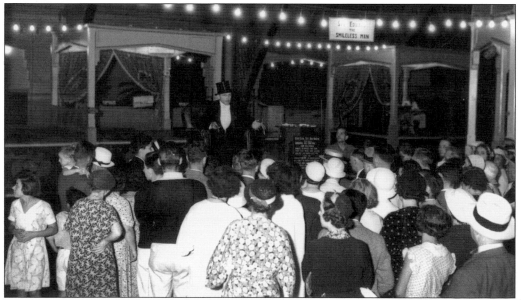

Five

SPORTS AND GAMES

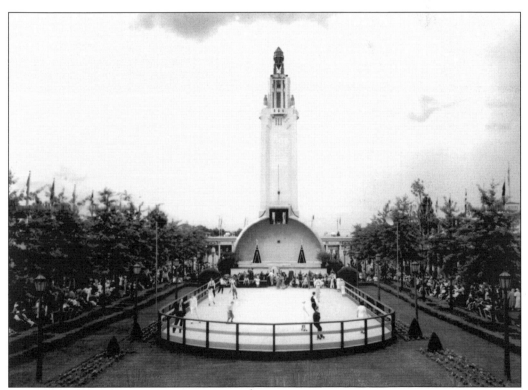

Roller-skating on the rink in front of the Music Tower was popular for a couple years in the early 1930s. It was discontinued on the outside rink in 1934 for insurance reasons. Eventually it was decided that any roller-skating would be done inside the casino, on a portion of the floor not covered with ice for ice-skating. Ice-skating, even during the summer months, was the favorite of patrons and less noisy than roller-skating. It would become the only kind of skating offered at Playland.

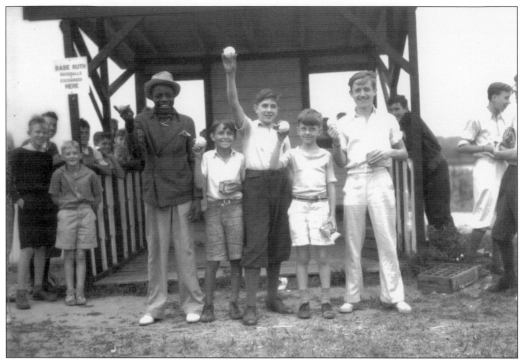

As America's pastime, baseball was important to the patrons of Playland. The sign behind the boys pictured here says, "Babe Ruth baseballs exchanged here." Baseball and the softball game pictured below were both played on the athletic fields along the shores of Manursing Island Lake. Americans during the early years of Playland strove to be physically fit. Many participated in athletics on a regular basis. Picnic groups and regular summer league teams played baseball and softball on the athletic fields available specifically for that purpose.

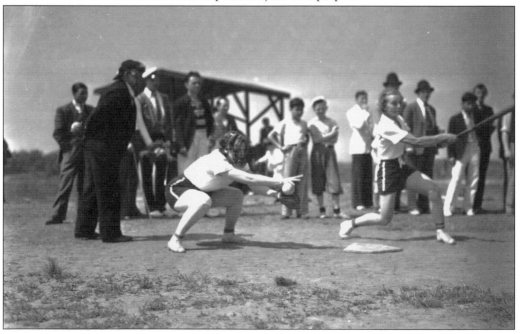

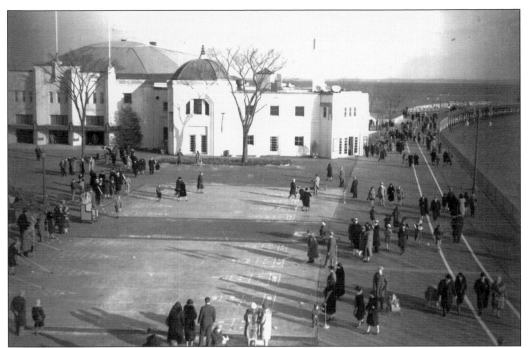

Shuffleboard was another of the popular games played at Playland. The shuffleboard courts pictured above were in a prime location, behind the boardwalk and next to the casino. Many patrons played for fun, and others competed in shuffleboard tournaments. The young lady pictured below hardly looks like she is dressed for an athletic event. Playing dressed in a skirt and shoes should bring a handicap. Shuffleboard was so popular that it was offered inside the casino several winters. The popularity of the game waned in the late 1940s. Obsolete shuffleboards were sold off at a price of two for $130.

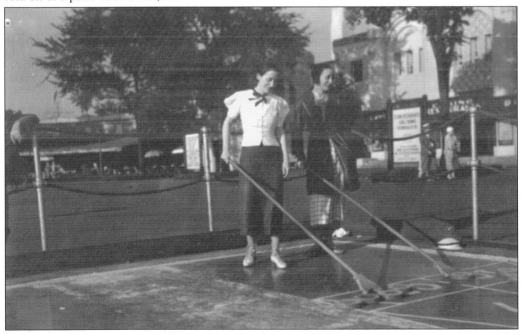

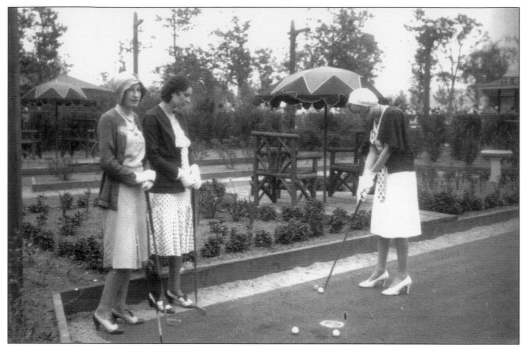

A game popular especially with the ladies was miniature golf. The young ladies pictured above, dressed in heels, skirts, and hats, appreciate the tamer aspects of the game. The miniature golf course pictured below was located by the boardwalk behind the casino very near to the picnic grounds. It has the characteristic decorative plantings of Playland with some fun trick contraptions to add to the interest of putting. The miniature golf course would be relocated to the front of the casino when the shuffleboard courts were removed.

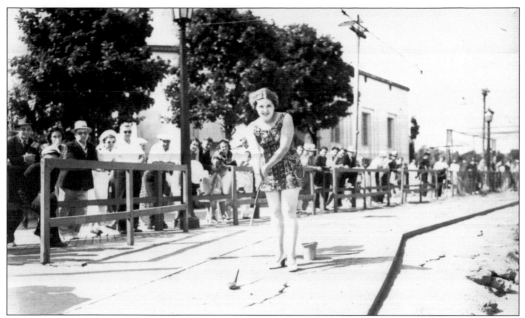

The patrons pictured above are practicing their golf swings. Golf driving was the concession of John H. Franklin beginning in 1930. For 50¢, a bucket of balls may be purchased and a driver rented. The fan would take his stand on the platform overlooking the sound and drive his bucket of balls as far into the water as his strength permitted. Anchored buoys marked the distance every 50 yards. The floating balls would be retrieved by youths in rowboats. During World War II, Franklin enlisted in the U.S. Navy. His brother Mike had already enlisted the year before, so John temporarily turned his and his brother's concessions over to the management of Augustus Rosasco. In 1943, the driving range became "swing bowling" since golf balls were not available during the war. The man pictured below is swing bowling.

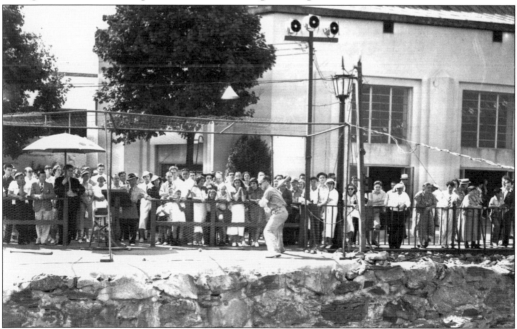

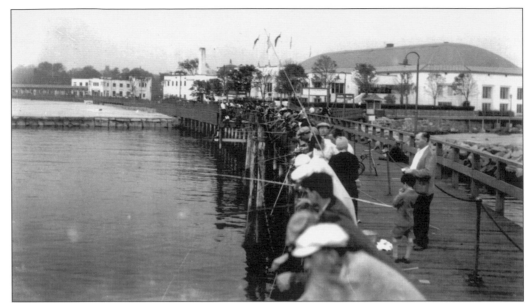

Fishing was another popular activity at Playland. The concession was run by Charles Tucci and his son for many years. Some people enjoyed fishing for relaxation, as the father and son pictured above. Others joined in fishing competitions, dropping their lines into the water off the boardwalk or going out in boats rented specifically for that purpose by the Tucci family. Also available for purchase from the Tuccis were fishing tackle and bait. To supplement his income from the fishing concession, Tucci also maintained a number of lobster pots in the Long Island Sound waters.

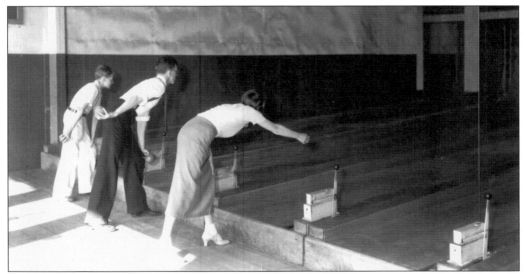

Skee-Ball, pictured above, has always been a staple in the game rooms or arcades at Playland. Skee-Ball alleys were used year round, in the summer in the arcades and in the winter in the casino. The game of skill used wooden balls that one rolled down an alley and up into a bull's-eye of holes. Each level of hole was a different point amount. The center hole or bull's-eye was the greatest point value. Later versions of the Skee-Ball machine contained an automatic ball counter and would stop counting points after nine balls had been thrown. This eliminated the use of balls from other lanes to up the person's score.

The woman at right appears to be practicing her foul shot technique. One of Augustus Rosasco's games was the Hoop-La basketball booth. Sinking a basket or two or three would bring a variety of prizes. College pennants were popular prizes during the early years of the park. Rosasco had most of the game concessions around the park. During World War II, with less people coming to the park, concessionaires were given breaks on their percentage fees.

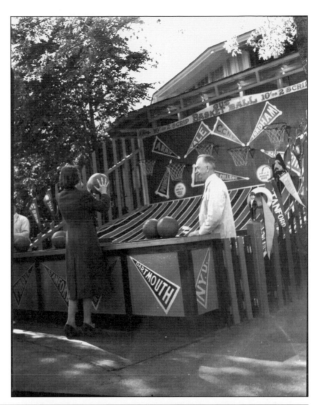

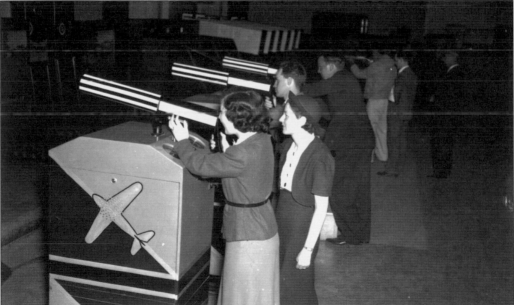

The machine guns pictured above were located in the casino game room. Especially popular with men and women patrons during the war, the four machine guns, galleries of items to shoot at, and shot holders were purchased from Fred Fansher for $1,092.22. Popular games would pay for themselves in a relatively short period of time. The location in the casino game room meant they would receive year-round use, increasing their earning potential.

Augustus Rosasco, owner of the old Gus's luncheonette previously located on the site of the new Playland Bathhouse, became one of the most recognizable concessionaires at Playland. Most of the arcade games along the parking lot entrance to the mall were owned by Rosasco, or Gus as he was known. Concessionaires would sign a contract with Playland to provide a specified game, amusement, ride, or attraction for a specific period of time. They were responsible for everything related to their concession, with the exception usually of the booth or building in which it was housed. They paid an agreed-on percentage of their profits to Playland. Pictured below is one of Gus's employees in his Gus' Games uniform sweater in the booth with doll prizes.

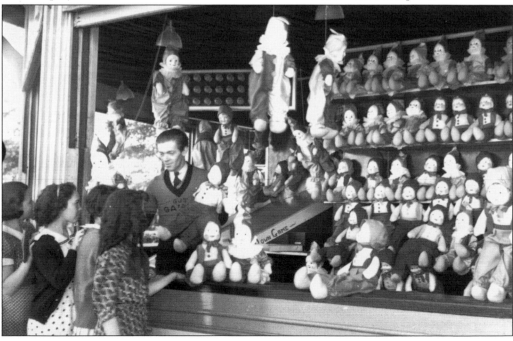

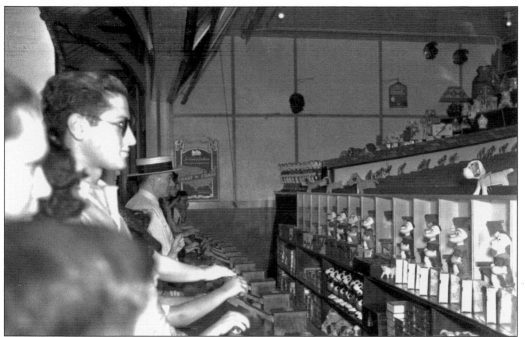

Another of Gus's games is pictured above. Patrons pay cash or scrip to play. As they pump the handle down, the water fills up in the tube connected to their handle. It moves the horse along the track. The fastest horse wins the prize. The boys below prefer more direct force to try to win a prize. They are throwing balls to knock things down. Concessionaires had to rely on signs or crowds attracting passerby patrons. No "ballyhooing" or hawking of amusements or wares was allowed at Playland.

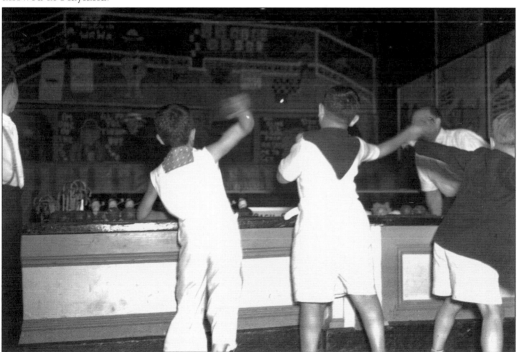

The Flight Tutors pictured above were yet more evidence of American's fascination with air flight. The attendant dressed in pilot gear sits on the propeller waiting for patrons playing out fantasies of being an airplane pilot. The Flight Tutors were introduced at Playland in 1934 and operated by Everett G. White.

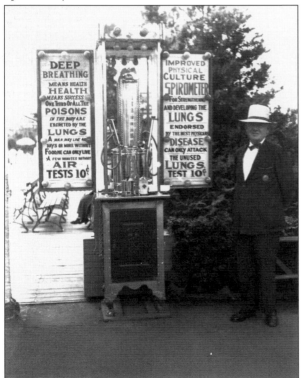

Health-conscious patrons often made use of the lung tester pictured at left. Warning people passing by, the signs extol benefits of using the improved physical culture "spirometer" for strengthening and developing the lungs. Purported to be endorsed by the best physicians, the machine tests lung capacity. It encourages deep breathing that can enhance the lungs' ability to remove toxins from the body. Peace of mind could be gained with just 10¢.

Michael H. Wallace, pictured at right in his later years, had a weight- and age-guessing concession at Playland for many years. Patrons would sit on the specially rigged chair attached to a scale. Wallace promised to guess their weight within three pounds or the patron would win a box of candy. Cost for this service was 10¢ or two scrip tickets.

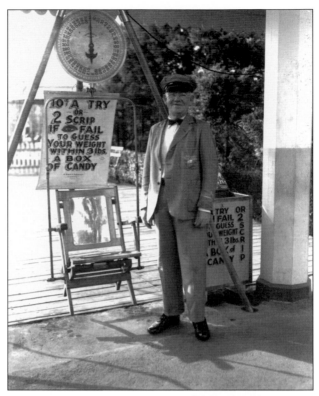

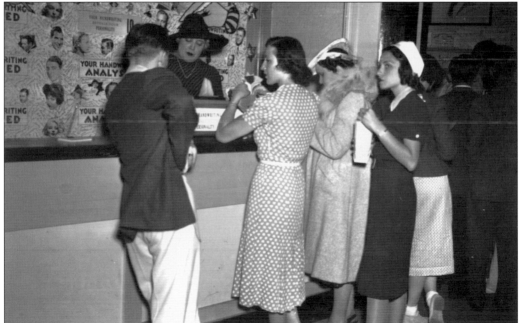

Patrons could have their handwriting analyzed at the booth above. According to the expert behind the counter, handwriting reveals one's personality. Next to the handwriting analysis booth is sketch artist Dorothy Durn's booth. Madame Ada Jordan, a palmist, and Michael Bliss, a silhouette artist, were also available for many years at Playland.

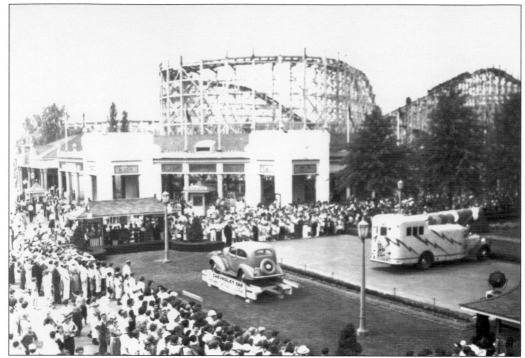

Crowds gather to buy chances on the Chevrolet parked here on the mall next to the Zilno the Human Cannonball's truck. Beginning in 1935, giveaways of cars boosted attendance that had dropped a bit during the Great Depression. In later years, Playland brought back the automobile as a giveaway. Pictured below in 1988, then–county executive Andrew O'Rourke is seen in the center. This Toyota, donated by Toyota City of Mamaroneck, was the grand prize to celebrate the 60th anniversary of Playland.

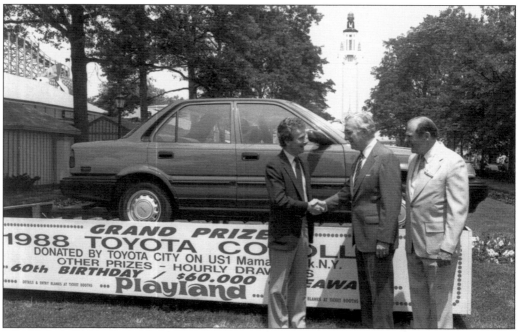

Six

CASINO

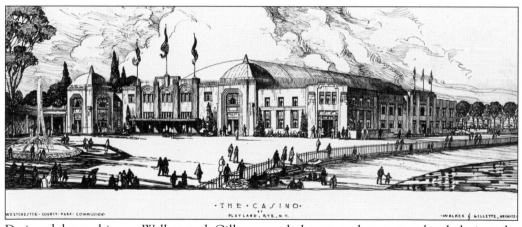

Designed by architects Walker and Gillette, work began and was completed during the 1929–1930 off-season. The casino officially opened on June 6, 1930. Built for a mere $1 million, it was reported to be the best place to dine and play in the eastern United States. And it would offer year-round entertainment for Westchester County residents. The beautiful new electric fountain in front is at the opposite end of the mall from the music tower. Inside is the dining room, overlooking the Long Island Sound, that seats 3,000 people. The ground floor contained the game room and grill. The main feature was a ballroom, the floor of which converted to ice that was a regulation hockey rink in the winter. Big bands played for the patrons of the restaurant. Special events and large parties were also held in the casino.

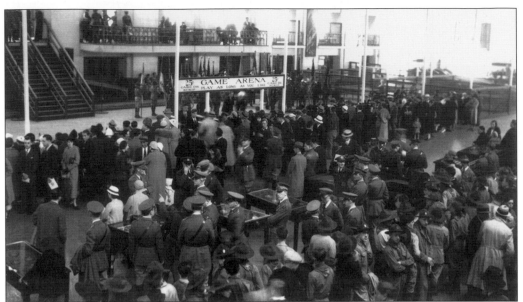

The game room in the casino is pictured above. This photograph is most likely following one of the special Memorial Day ceremonies. Boy Scouts can be seen in the background with flags. Military men in all areas of the service are involved in the games or milling around. Signs advertise games for 25¢ cash or scrip. Unlike European casinos, the game room provided wholesome athletic games for which Americans had shown a preference, instead of the usual gambling games found elsewhere. Patrons were encouraged to play as long as they liked. Servicemen in uniform from the United States and its allies were granted a special discount on tickets beginning in the spring of 1942.

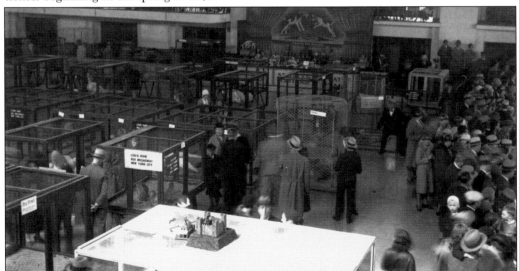

This photograph is also of the inside of the casino. The first annual Playland Pet Show was held in April 1932. Sponsored by Spratt's Dog Food, the Central Westchester Humane Society was allotted three booths to exhibit animals to be given away to good homes. Professionals and amateurs brought their pets and paraded them before judges. Commissioner Edward P. Mulrooney of the New York City Police Department gave consent for the exhibition of the New York City kennel of police dogs. Many other pets and animals were on exhibit as well.

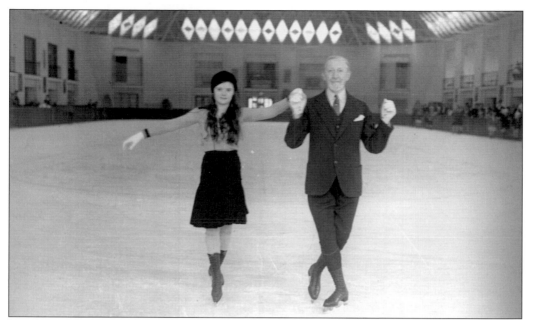

Ice shows were a popular draw to the ice area. Francois LeMaire and Maudie Reynolds were professional skaters who also gave skating lessons. Constant use of the ice rink enabled Edward L. Ensign a good living sharpening skates and also offering skates for rental and purchase. Regular sessions of skating for the public were scheduled throughout the week. The Rye Figure Skating Club has had a long-standing contract with Playland for use of the ice rink for figure skating competitions, shows, and their annual ice carnival. The Middle Atlantic Skating Association had speed racing on Friday nights.

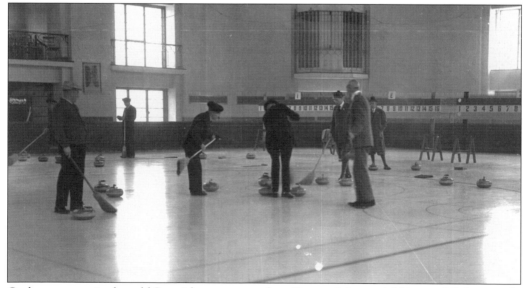

Curlers, experts in that old Scottish sport, came from Boston, Montreal, Utica, and Schenectady to compete with a dozen Westchester County Clubs. The Playland Casino Ice Rink was reportedly unrivaled among ice rinks across the country. The ice rink was on one end of the main floor, and an orchestra was on the other end, with dancing on the regular floor in between. Tables were arranged around the floor in true cabaret style.

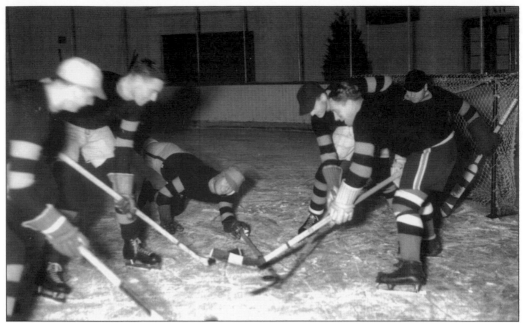

Although the casino was closed for the winters from 1942 to 1944 due to the war, when it reopened, ice hockey had become popular. The Westchester Hockey Organization held league games at the casino, as did many area high schools. Two huge ice plants, one with a 55-ton capacity and the other with a 35-ton capacity, were installed early on in the casino to cool the ballroom in the summer and for freezing ice in the fall, winter, and spring. The ballroom could be transformed into a skating rink in approximately three hours.

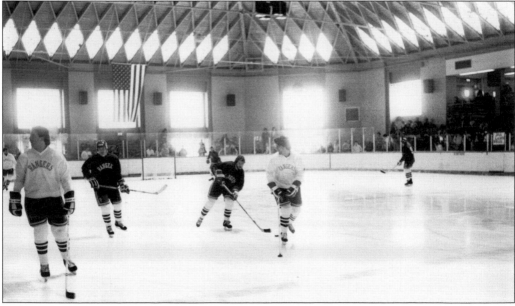

In later years, Playland ice rink was the training home of the New York Rangers. Hockey fans could watch their favorite players practice. They could actually skate on the same ice as the professional players. Area high schools, colleges, and private clubs continue to use the Playland rink for practice and games.

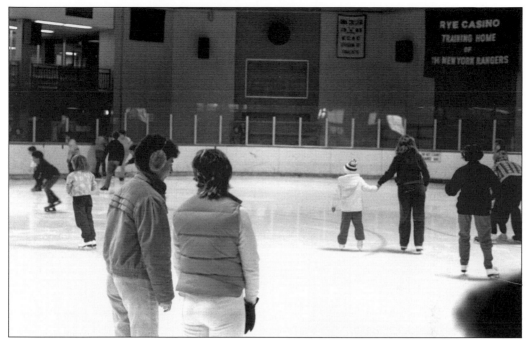

Regularly scheduled free skating times were still popular in this photograph from the 1980s. Skaters could use the main rink, the children's rink, or the studio rink. Casino ice rink birthday parties were popular with children and their parents. Refreshments sold nearby and benches for resting and watching the skaters made the ice rink a fun place to be.

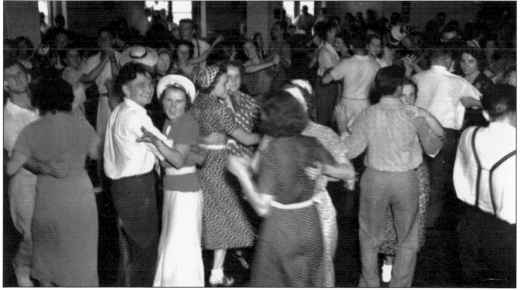

Dancing on the terrazzo floor to big bands or to music furnished continually via the "Playland Miracle Music" system was originally possible from May to October when the ice rink ceased for the summer. In 1931, due to the popularity of both activities, the large floor space was split to accommodate both dancing and skating year-round. Famous dance contests were held in the ballroom. Surrounded on three sides by water, dancers in the casino would stroll out to the boardwalk areas to cool off and rest between dances.

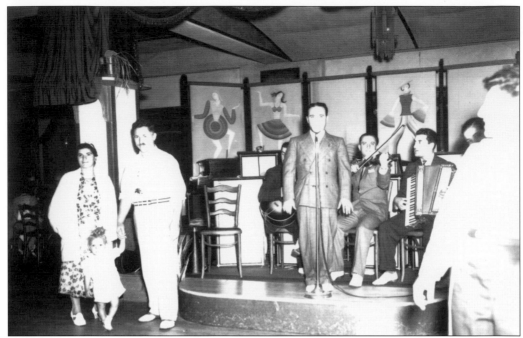

The upstairs dining room pictured above and below offered excellent dining, dancing, and relaxation while listening to wonderful live music. Elegant surroundings, columns, draperies, and hand-painted murals can be seen behind the band, adding a sophisticated touch to the ambiance of the room. The balcony promenade runs the full length of the building on the north side facing the sound. During Prohibition, no alcohol was served at Playland. In 1934, the board of supervisors voted to allow wine and beer to be provided at table service only in the restaurants. It was 1937 before hard liquor was allowed to be sold at bars and restaurants on the Playland property. At no time was it permitted to sell alcohol to employees on or off duty. Casino dining rooms were run by concessionaires who were well-known and popular caterers.

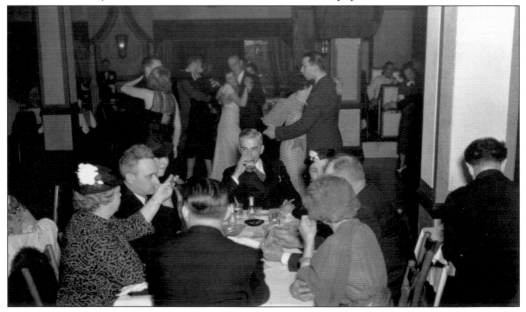

Seven

POOL, BATHHOUSE, AND BEACHES

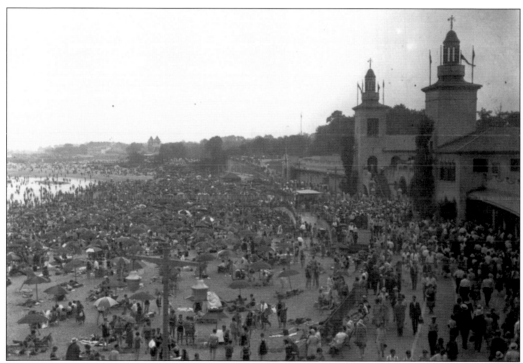

On the first day of the Fourth of July weekend in 1928, 10,000 people had signed in to use the bathhouse by 1:00 p.m. Another 6,000 took their turn in the afternoon. Only those in bathing suits were allowed access to the beach. To keep the sand safe and clean, only paper cups, no glass bottles, were allowed on the beach. The new modern bathhouse was built of fireproof concrete block. A covered passageway also of concrete construction leads from the bathhouse to the beach for the convenience of bathers and to avoid offending individuals on the boardwalk by their lack of dress.

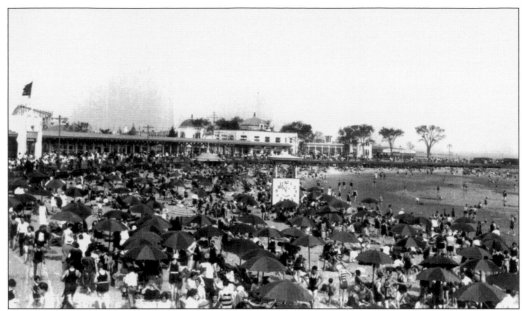

The large clock on the beach in the photograph above gave the time of the next high tide. Another sign at the entrance to the beach read, "Police Warning! Bathers are not permitted to be off the beach unless properly covered. Offenders to this regulation subject themselves to arrest without further notice." Westchester County and the Playland officials were very serious about maintaining a fun, family place, free from the rowdiness of the old Rye Beach resorts.

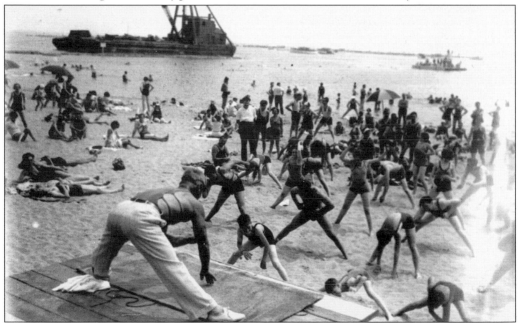

Bathers join Professor Groll's exercise class on the beach at Playland. Bathers paid 50¢ for a locker in the bathhouse. Should they forget their bathing suit, for another 50¢ they could rent one for the day. For a dollar, they could rent the more fashionable wool bathing suit. Those suits were definitely one size fits all. The barges in the background are depositing more sand that was sucked off the bottom of the Long Island Sound by dredge barges to maintain and enlarge the beach.

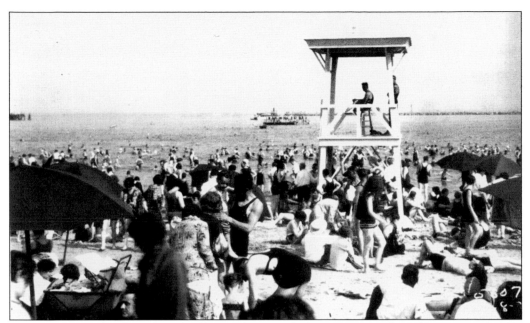

The lifeguard in the chair above had his work cut out for him. Most people in the 1920s and 1930s did not know how to swim, hence the name bathers instead of swimmers. Life-saving techniques were rather crude in 1928. Although in 1922 the American Red Cross established national institutes to train individuals in water safety and first aid, mouth-to-mouth resuscitation would not be employed until 1958. Umbrellas and beach chairs could be rented at the bathhouse.

The beach tunnel entrance from the bathhouse can be seen in the photograph above. Parents of the children lounging on the sand have little fear of illness from swimming in the water. Dr. George J. Hogben, a Westchester County health officer, checked water quality on a regular basis. He determined that all Rye beaches were safe for swimming and were actually far above the standard set by the New York City Board of Health.

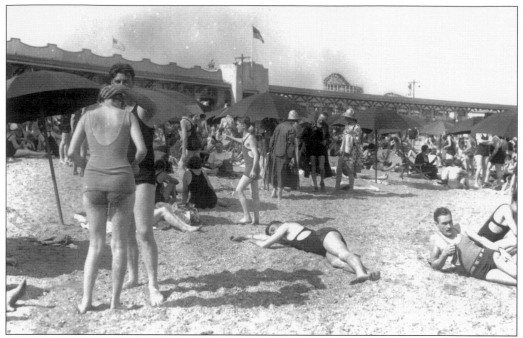

Bathers basking in the hot sun on the beach were afforded the guidance of a Tan-o-meter to encourage successful tanning. With a "healthy tan" now the rage, the Tan-o-meter was advertised as the first scientific guide for the general public on how to get a healthy tan. The meter was installed on the beach at Playland. It consisted of a large color chart with measurements and calculations estimating how long a person should stay in the sunlight to become "becomingly" tanned.

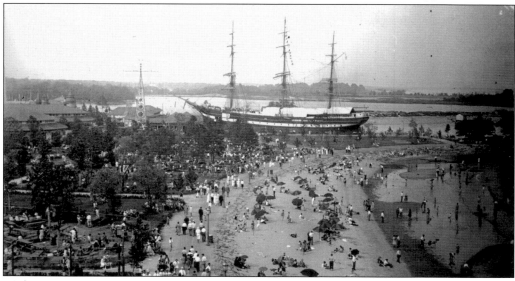

With increasing crowds at the main bathhouse and beach, the other beaches at Playland were also filling to capacity. The beach in the photograph above is located between the picnic grounds and the water along the north boardwalk. The clipper ship can be seen at its mooring in the background. The absence of changing facilities did not seem to deter people from using this beach. Another option for bathing was the beach on Manursing Island Lake. A small bathhouse was available for patrons at that location.

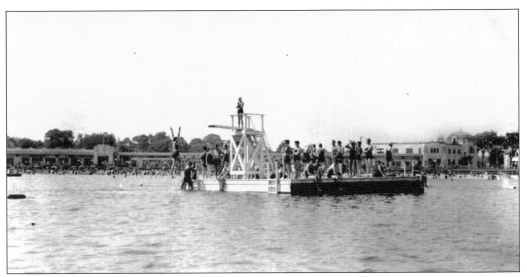

When not in use by Inez Wood and her bevy of bathing beauties, the raft and diving boards were available for the use of swimmers. It was a good distance from the shore, and only competent swimmers were able to make the distance safely. Swimmers could bask in the sun on the raft or practice diving skills. It was very important, however, for them to always be on the lookout for passing boats that did not always notice the swimmers who were sharing the space.

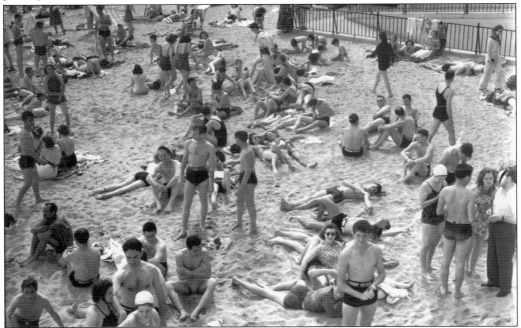

For several years, Westchester County resisted the requests to allow "topless" bathing suits for men. One college professor was reported as deploring the fact that the commission deprived underexposed males to the healing benefits of the sun. The park superintendent at the time expressed his fear that the nude male torso might detract from the beauty of the landscape, which the commission had created at such pain and expense. While most of the rest of the country had already allowed the practice, Playland finally became a topless beach—for males— for the summer season in 1937 after a decree by the parks commission in November 1936.

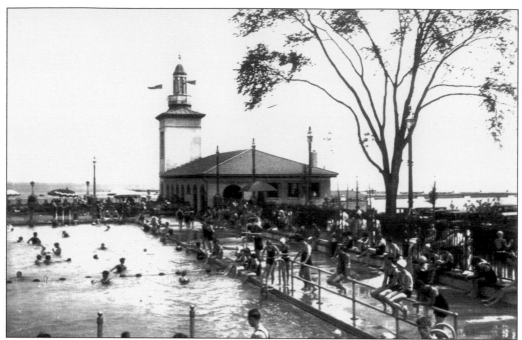

The freshwater, Olympic-sized swimming pool opened in 1929 with a restaurant on the same level. Gertrude Ederle, the first woman to swim the English Channel, was in charge of the Playland pool. Her initial appearance was on June 6, 1929, along with Johnny Weissmuller, freestyle Olympic champion and future Tarzan. The pool is situated at the entrance to the amusements and center and adjacent to the Playland Bathhouse above the beach.

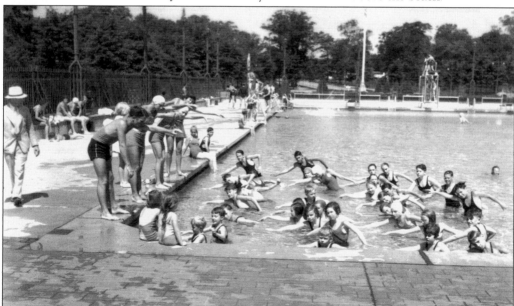

The pool was said to be one of the finest in the East. It was 150 feet by 75 feet with a graded depth from 3 to 10 feet. It had a modern filtration system that provided a complete change of water every seven hours. Free swimming classes were given daily at the pool. From its opening, it was the site of the Westchester County swim meets.

Eight

ON THE WATER

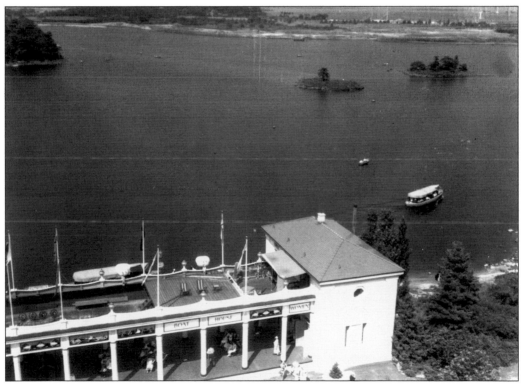

In the aerial photograph above looking over the top of the boathouse toward the Long Island Sound on the right, much of the 85-acre Manursing Island Lake is visible with the islands providing areas for the landing of rowboats and canoes. The shore on the far side is the lake beach. The initial concession for the boathouse including all boats to be used on the lake and much of the sound was contracted by Lewis Berger. He was responsible for the maintenance of all boats and the purchase of any additional ones that were needed. He paid an annual fee to Playland for the concession.

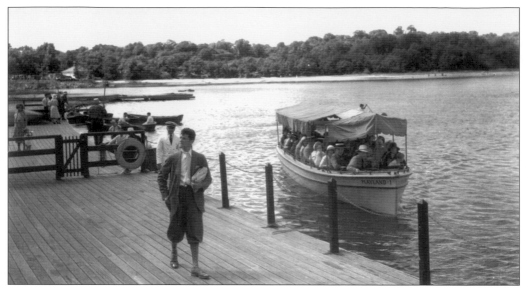

The man seen here is waiting for the arrival of the boat that has been cruising leisurely around Manursing Island Lake. The boat is one of four launches obtained from the City of Philadelphia following its sesquicentennial exposition. Each launch is 32 feet long and can seat 35–40 people comfortably. Built with solid mahogany decks and brass fittings, they originally cost $5,000 each. Westchester County Parks Commission purchased them for Playland for a total of $4,600 or an average of $1,150 each.

The boats in the photograph above were supplied to Playland as a concession of the American Waterways Company. Although said to be as easy to drive as an automobile, the 20 boats of lightweight steel hulls became badly pitted by the salt water. These boats were replaced by mahogany boats produced by Kaymo Electric Motorboats and operated by M. C. Hull. These boats were electrically powered and easy to maneuver. The mahogany boats lasted many years, even in the salt water.

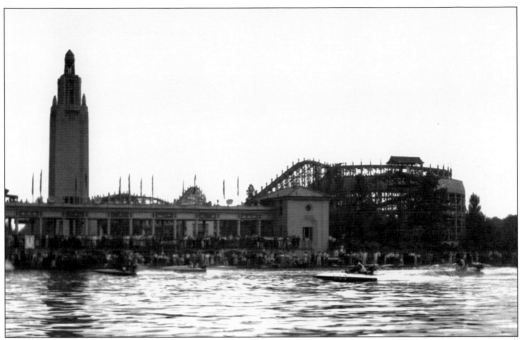

Here crowds gather to watch the speedboat races on Manursing Island Lake. The boats were gasoline operated and very noisy. Many complaints were made about the noise and the speed at which these boats traveled in and around other boats, particularly when they were driven inside the breakwater near the dock and the beach. Repeated warnings were given to the concessionaire. Being gasoline powered, they were not used during the war years due to gasoline rationing.

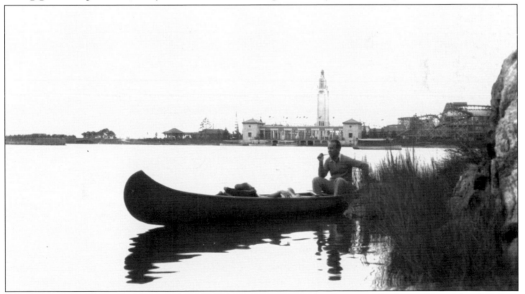

In contrast to the speedboats is the canoe pictured above. This couple floats leisurely along in the quiet near the islands. Little effort is needed with the paddle as the man enjoys his pipe. His companion is lounging on the floor of the canoe. Quite possibly they will be stopping at one of the islands for a picnic. The boathouse and music tower can be seen in the background across the lake.

The Custer Paddle-About boats in the photograph above were supplied by Custer Specialty Company. The parks commission operated the ride, retaining 65 percent of the revenue and paying 35 percent to Custer Specialty for the use of the equipment. The boats were fully enclosed and protected from rough water. The extremely wide seats fit three passengers side by side. The pedal arrangement allowed for pedaling by one, two, or three persons at the same time.

The photograph above, taken in the 1980s on the lake, shows that paddleboats are still popular. Larger and made primarily from fiberglass, they can seat up to four adults, two in the front and two in the back. The two people in the front of the boat are responsible for pedaling. Across the water is a different kind of paddleboat. It is used for taking large groups of people leisurely around the lake.

Nine

GETTING TO THE PARK

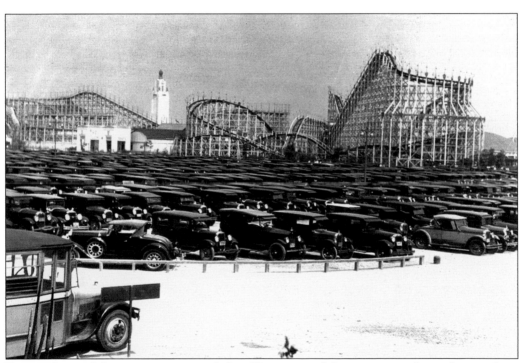

During the weekdays, it was estimated that 90 percent of the visitors to the park were from Westchester County. On the weekends, it was closer to 50–60 percent, as attendance was tracked for the first several years since the park opened. Most people arrived by bus. The licensed bus lines paid a seasonal fee of $150 per space; unlicensed bus lines paid $200 per space. So many people came to the park from the opening that in June 1928 the Post Road from Port Chester to Rye had to be widened to 65 feet.

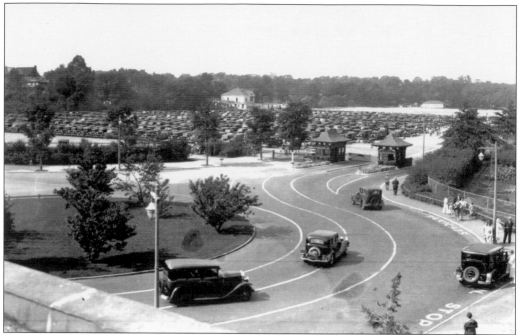

The traffic circle here was one of the first things seen as patrons arrived at the park. It was always planted with bushes and flowers, and the grass was manicured. Roadways were kept spotless. The attendant looking out of her booth toward the cars below would see most cars from Westchester County, Manhattan, and the Bronx. After the George Washington Bridge was opened in 1931, many more cars arrived from New Jersey and beyond. A parking lot survey in August 1928 indicated that cars came from states from Maine to California to Florida. Others came from Upstate New York and Canada.

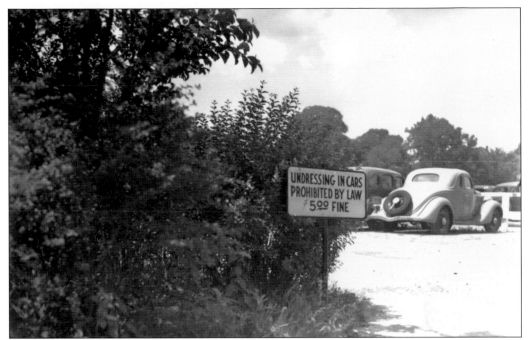

Keeping in mind the problems created by the previous amusements located on these properties, the Westchester County Park Commission endeavors to maintain strict standards for a fine family environment. No lascivious behavior would be tolerated, as indicated by the sign in the parking lot above. Undressing in cars was prohibited by law. Offenders will be levied a fine of $5, 10 times the cost of changing one's clothes in the bathhouse provided for that purpose.

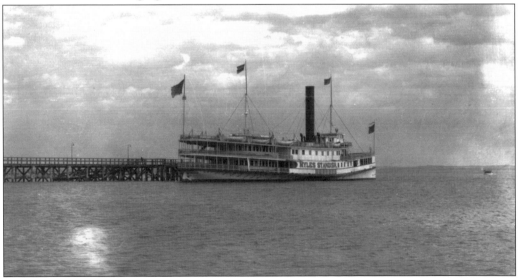

The steamship *Miles Standish* at the Playland steamship dock above was scheduled to participate in the special ceremonies on opening day but was delayed by fog and forced to remain on the other side of the Long Island Sound in Huntington, Long Island, with some very disappointed passengers. Steamships brought visitors to Playland from Connecticut, New Jersey, Long Island, and all parts of New York City, including Staten Island, the Battery in Manhattan, Brooklyn, Queens, and the Bronx.

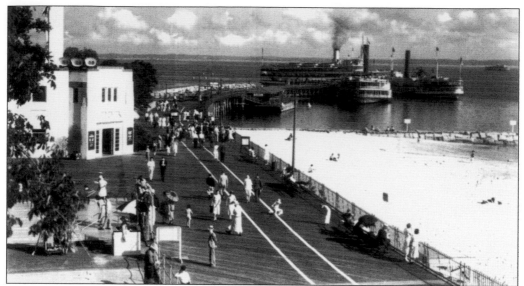

Docked above are the *Americana*, the largest of the steamships with the rows of lifeboats on the top deck; the *Miles Standish* with its bow facing toward the beach; and the *Warwick* on the right. Meseck Steamboat Corporation owned and operated the steamships to Playland. As the ships docked close to bathing waters, there was often a concern about the discharge of refuse, debris, sludge, and other unsanitary matter into the water. It was often difficult to determine which boats were responsible. Playland authorities were given the authority by the Coast Guard to restrict boats in their "private harbor."

The crowds part in the photograph above to allow the beach tram to pass through. A one-way trip cost 5¢. Riders could get on and off anywhere. Operators were paid in scrip or cash as the rider got on the tram. Unfortunately, the tram only ran along the boardwalk from the bathhouse to the clipper ship. The parallel line path is marked on the photograph at the top of the page. Most people preferred to walk along the boardwalk, so the tram was discontinued after a few years of use.

Thousands combined the pleasures of a steamboat ride with a trip to Playland until about 1957. A hostess would often greet passengers as they entered the boat. Many boats had entertainment on board as well as dining and refreshments. The passengers disembarking above often brought picnic supplies and food with them as they planned to spend the day and into the night before climbing on another ship for the trip home. During busy times, additional boats were added to get the crowds home from the park.

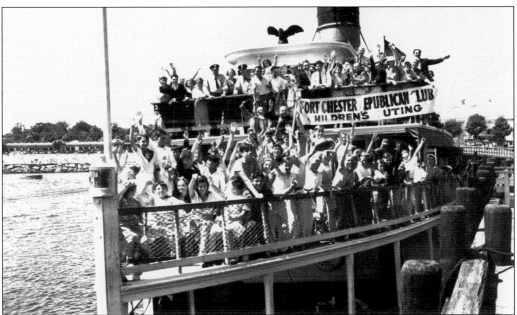

Many groups, churches, and clubs, such as the Port Chester Republican Club's children's outing pictured above, would take the steamship to Playland. Groups received a reduced rate, and the fun began before the group even got to the park. Unfortunately, during World War II, the government took over some of the ships for use by the military. Attendance at the park was down, and fewer ships were needed. Often only a single run was needed each day.

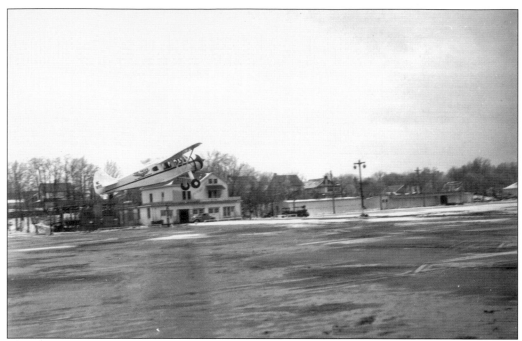

The plane taking off from the far end of the parking lot at Playland in the photograph above is headed back to the Westchester County Airport. Airplane service was established in early 1928 to meet the needs of the select few who would arrive at the park by air. Seaplanes, like the one taking off in the photograph below, were part of Atlantic Airways of New Rochelle. Permission was granted by the Westchester County Parks Commission for a "flying field" from which to take passengers on trips from the park. Area residents complained about the noise of the hydroplanes, saying it was impossible to have a conversation on their front porch. The commission ignored the complaints.

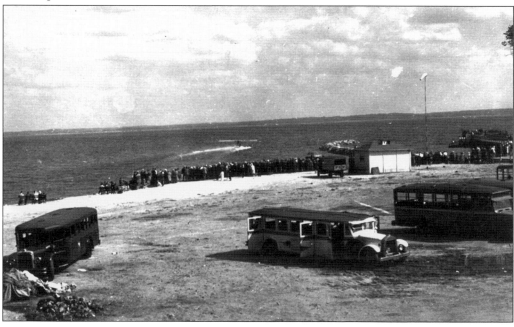

Ten

AROUND THE PARK

The favored activity at Playland next to bathing and amusements was eating. There were any number of great places to eat at the park, but one of the best outdoor eating places was the rooftop garden restaurant on top of the bathhouse. Run by Hobart and Georgia Morgan for many years, patrons could sit under umbrellas and look out over the Long Island Sound while the cool breezes blew in off the water.

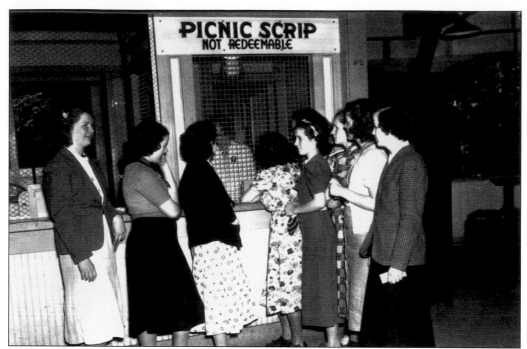

Picnic grounds were accessed using scrip. Once in the picnic grounds patrons had at their disposal fireplaces, running water, and a cafeteria, where lunches and drinks were available. Free kitchen access was available for heating of food and baby bottles. The spacious shelters were available to keep out the hot sun and the occasional rain shower. The picnic groves were shady, cool spots during the warm weather due to shade trees planted especially for that purpose. Private parties were accommodated.

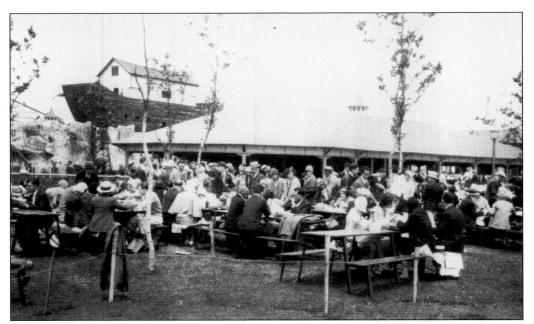

The picnic grove pictured here sits between Noah's Ark and the clipper ship. The covered picnic shelter is behind the patrons seated at the tables. Picnics and outings were held by fraternities, political associations, and business concerns, as well as churches, shops, and Sunday schools. As many as 17 group picnics could be held in the grove at one time. During the 1929 season, 617 organized picnics and excursions were held at Playland.

One of the groups traveling to enjoy Playland was the St. John's Windish Lutheran Church from Bethlehem, Pennsylvania. St. John's is the only Windish Lutheran church in the United States. The Windish Lutherans are from the Prekmurje mountainous area of Slovenia. While most Slovenians were Catholic, the Windish are Evangelical Lutherans. The church was founded in 1910. The church members pictured here in 1929 are enjoying their time at Playland some 125 miles from home.

Isidore Feuer was the concessionaire for many years for the souvenir shop seen here. The two connected stores fronting on the boardwalk sold assorted bathing attire, notions, toys, souvenirs, and bathing equipment. He also sold caps, visors, bags, sneakers, and shoes. The boy here is buying a sailboat for use on the water. The store opened with the park, but like most concessionaires, Feuer had trouble paying his concession fees to Playland during the war. Special arrangements were made for most longtime concessionaires.

Abbott's custard was a favorite treat at Playland. Soft ice cream was especially good on a hot summer day. It cost only 10¢ and was a concession of the Abbott family. Most refreshment stands were operated by Playland. The Von Wedel Laboratory was engaged to make weekly inspections of all food and refreshment services.

The couple ordering a meal at the table seen here is in the colonnade restaurant. Waiter service was available in a relaxed atmosphere where patrons ate surrounded by beautiful scenery and gardens. Atmosphere was an important part of Playland. A great deal of money and effort was spent on making the grounds beautiful. Thousands of bulbs were planted every year, and annuals were added each spring. Shrubs were carefully manicured, and grounds were always kept clean.

Another favorite place to eat was the Japanese Tea House. The Japanese Tea House opened with the park in 1928. It was tucked away at the lake end of the mall near the Long Island Sound, giving wide views of the sound and the lake. It had bright colors, matting floors, gardens with a running brook, and gay windows that slid back to let in the salt breezes. The food was provided by Claribel Hill of Bronxville, known for her excellent cuisine.

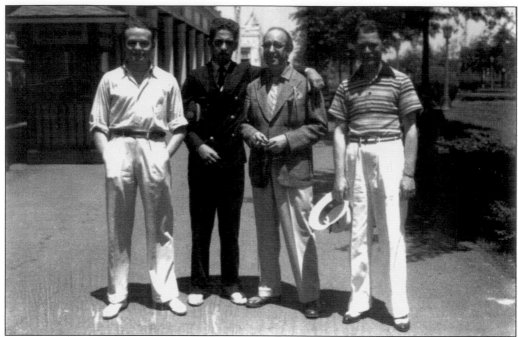

One never knew who could be seen around the park. Actor Ed Wynn (second from right), pictured here with some of his friends, was the Texaco Sky Chief before Milton Berle was a Westchester County resident. Playland was known as a clean, fun place to be. Anyone could get lost in the crowds and have a good time.

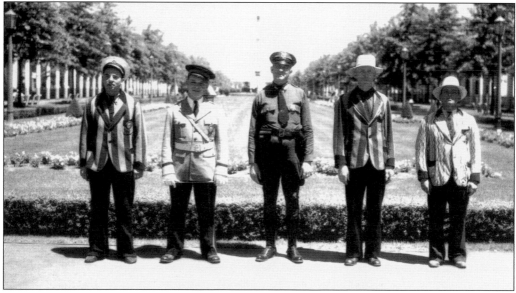

Some important employees of Playland are pictured above. Their uniforms indicate their position. Playland police had a variety of responsibilities over the years, and the most important of those responsibilities was to contain rowdy behavior that was such a concern since the days of the old Rye Beach amusement parks. In 1928, before the park opened, it was decided by the parks commission to place a few plainclothes policemen in the park along with the uniformed officers. Whatever the plan, it worked. Incidents at Playland were rare.

The music tower is pictured here in June 1929. Not just aesthetically beneficial, the music tower provided restrained, harmonious music that was diffused through the park at all times by specially placed speakers. No raucous, hurdy-gurdy band, organ-type music would be heard at Playland. A Gothic tower more than 120 feet high, the music tower was lit at night by colored lights.

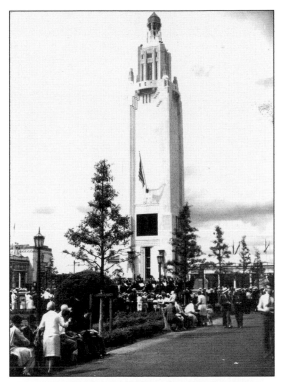

The voice of Playland, pictured above, was responsible for making important announcements. Through the park broadcasting system in the 1930 season alone, 298 children were restored to their parents. Doctors were paged, and others who were needed at home or reached in emergencies could be contacted as well. Radio machines also produced fresh-from-the-source renditions of the best artists, orchestras, and bands. During World War II, important announcements were made about air raid drills and blackouts.

The Native American exhibit was located behind the music tower. It was a concession of Milo Billingsley. It was set up to show the Native Americans in their habitat. The fenced-in area included the teepee and all sorts of other things on display, including the people. It was a hit with Playland patrons.

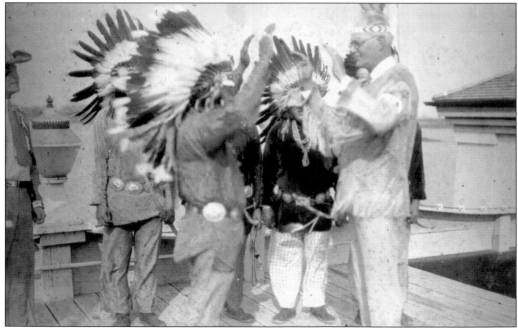

The Native Americans pictured above with Frank Darling were brought to Playland to participate in an end-of-the-first-season pageant depicting the historical background of Westchester County. In the exhibition showing the growth of the county from Native American and Colonial days, 200 participated. Hopi were brought to Playland since no other Native Americans were available locally. The pageant included scenery, costumes, horses, and campfires.

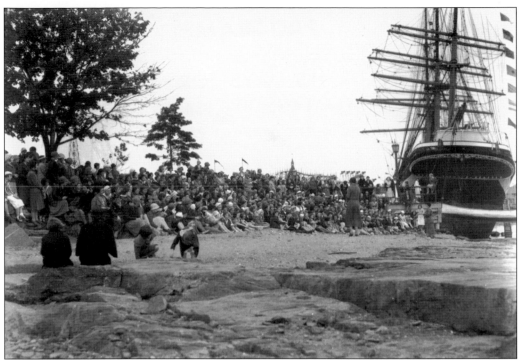

Girls Scouts, pictured above, and Boy Scouts, pictured below, both held annual jamborees at Playland. Using the park in the spring before it was officially opened or in the fall after the amusements had closed enabled both groups to take over large areas of the park for their activities. The Girl Scouts have congregated on the picnic grove and beach area near the clipper ship. The Boy Scouts are performing ceremonial parade movements in the parking lot, near where they have set up their tents, seen in the background on the right side of the photograph below.

PROGRAM

CHILDREN'S DAYS FOR CHINA
PLAYLAND, RYE BEACH

FOR THE BENEFIT OF UNITED CHINA RELIEF

CAMPAIGN FOR YOUNG CHINA

Mrs. Henry Seidel Canby, Director
Judge Geo. W. Smyth, Chairman,
Westchester County Division

MONDAY, JULY 7th, 1941	TUESDAY, JULY 8th, 1941
FRANK BUCK	EZRA STONE
ROBERT "Believe It Or Not" RIPLEY	JOSE FERRER, Star of the Recent Hit Revival "Charlie's Aunt"
TOY & WING, Popular Oriental Dance Team	
THE FOUR POLKA DOTS	MARY SMALL, Radio's Brightest Singing Star
"TERRY & THE PIRATES" Presents Thru the Courtesy of Their Creator Milton Caniff	PATSY O'CONNER, Featured Child Actress of "Panama Hattie"
TERRY LEE.....Robert Morrow, Jr. THE DRAGON LADY..Patricia Ryan BURMA............Rona Brewster	LOULIE JEAN, Featured Singer of Fefe's Monte Carlo
CAPTAIN ROWLAND TIEBOR AND HIS MIRACLE SEAL	JACKIE AYRES & ARTHUR QUINN, Currently Appearing in "Life With Father"
LI LING AI............CHINESE SONGS	CAPTAIN ROWLAND TIEBOR AND HIS MIRACLE SEAL
JEAINNE PARRILLO, Courtesy of the Horn & Hardart's Sunday Morning Children's Hour	HARRY FOSTER WELCH, The Original POPEYE
THE BURNETT BROTHERS, Courtesy of the Horn & Hardart's Sunday Morning Children's Hour	BOBBY HOOKEY, Courtesy of the Horn & Hardart's Sunday Morning Children's Hour
CHINESE SWORD DANCE Gertrude Ng Lilly Chinn Victoria Tom Lillian Dong	JACK VINCENT, Courtesy of the Horn & Hardart's Sunday Morning Children's Hour

Accompanist Alberta Masiello

DIRECTOR OF ENTERTAINMENT . . . ALFRED STERN

ENTERTAINMENT COMMITTEE

CHAIRMAN . . . ED SULLIVAN

Alton Alexander	Ann Edison	Hunter Mann
Milton Caniff	C. V. Farley	Paul Mosher
Jack Charash	George A. Hamid	John L. Toohey
Robert Coe	Dick Hyman	Elaine Wayne
	Ruth Yates	

Transportation of Artists thru the Courtesy of the Automobile Merchants
Association of New York. Additional Transportation, Courtesy of
Raymond Loewy, Industrial Designer.

Ed Sullivan, Port Chester's noted Broadway columnist prior to his nationally known entertainment show, was the chairman of the United China Relief gala held at Playland in July 1941. The two-day celebration for the Campaign for Young China marked the fifth year of China's defense of her homeland. Proceeds of the event would benefit Chinese war orphans and children suffering from disease and malnutrition. A list of celebrities above gave their time to the event.

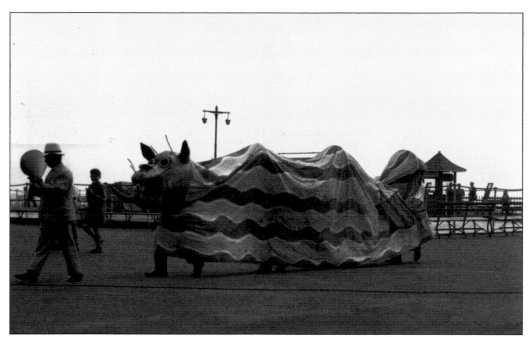

The gala entertained 10,000 American, British, and Chinese youngsters who attended the two Children's Days for China. The concern was for the 50 million people driven from their homes by the war and the bombing raids in China. It was advertised that $1 would provide immunization for 50 people; $5 would disinfect 250 wounds; and $20 would keep a refugee alive for a year.

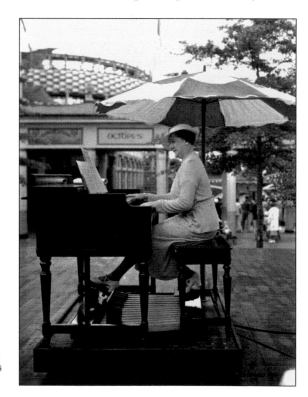

The woman pictured at right is playing the organ in the entertainment area in front of the music tower. Almost continuous entertainment was available to the patrons of Playland. Large bands and orchestras, singers and other entertainers, circus acts, and light shows provided a great time for all. No one was ever bored at Playland.

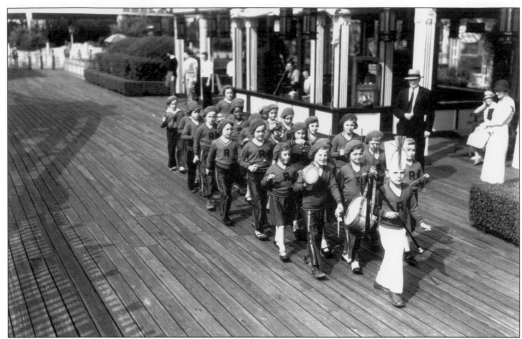

Children's events were popular draws at Playland. Whenever children participated in an event at Playland, their parents and families came to watch. The more people at the park the more funds in the Westchester County coffers and ultimately less money that Westchester County taxpayers had to provide. The parade above is marching along the boardwalk in front of the casino on the way to the bathhouse and beach. The lineup below is the baby show and parade that was held for three days the end of July in 1934. It would take a strong judge to pick just one of those adorable children as the most beautiful baby in Westchester County.

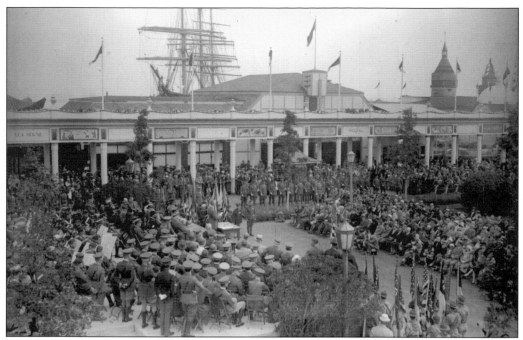

The Memorial Day celebration in 1931 was an impressive spectacle. As one pans the crowd, members of all branches of the military, groups of Boy Scouts, dignitaries, military bands, and spectators can all be seen. Speeches were made to the crowd from the stage seen here in the center of the photograph in front of the music tower at one end of the midway. The clipper ship can be seen docked at its pier in the background.

The guest speaker in 1931 was Maj. Gen. Smedley D. Butler, United States Marine Corps. One of the most colorful officers in the United States Marine Corps' long history, he was one of two marines who received two Medals of Honor for separate acts of outstanding heroism. While his loyalty to the corps remained strong, he began to doubt the policies of his government and authored a book, *War is a Racket*. He went on the lecture circuit. He died in 1940. Pres. Franklin Roosevelt named a destroyer, the USS *Butler*, for General Butler in 1942.

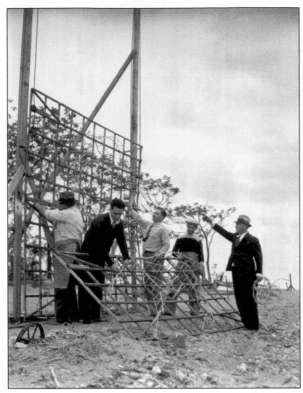

Fireworks have always been an important part of the summer season at Playland. For most seasons, with the exception of the years of World War II, the fireworks displays occurred at least two nights a week and on the holidays of Memorial Day, Fourth of July, and Labor Day. In the 1930s, the Pearl Fireworks Company of Providence began assembling the fireworks on the grounds at Playland, as shown in the photograph at left. The fireworks were set off on Manursing Island and could be seen from all around the park. The best viewing site was the along the north boardwalk. The clipper ship, as seen in the photograph below, advertised through a sign on the sail in the bow that the deck of the ship was the place to watch the show.

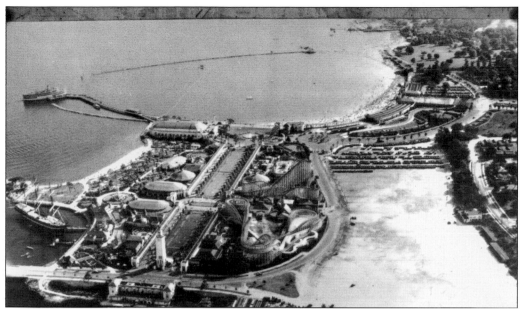

The aerial view of Playland seen above provides a complete picture of the park. A small piece of the 80-acre Manursing Island Lake is at the very bottom of the photograph on the left side. The dock and boathouse sit at the bottom edge of the park. The large area at the bottom right side will eventually be all parking lots. At the top of the parking lot are the bathhouses, restaurants, and boardwalk, which curves along the break wall, providing an 800-foot opening to the sheltered beach area. The mall where the attractions flourish is clearly delineated in the center of the amusement area. The largest building at the top, left end of the mall is the new casino. Ships dock at the end of the pier and wait to load and unload passengers arriving and departing the park by water. The aerial view in the photograph below from the 1980s is very similar. A fire in 1966 burned the amusements to the left of the music tower, and the Airplane Coaster has been removed. The trees have all grown to provide extensive amounts of shade, and the parking lot is completed.

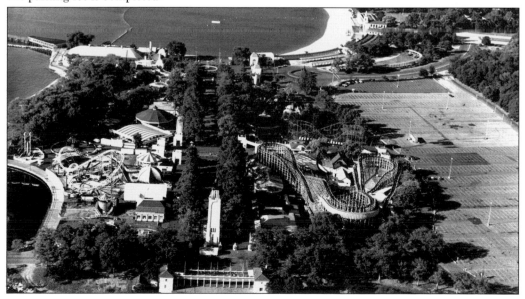

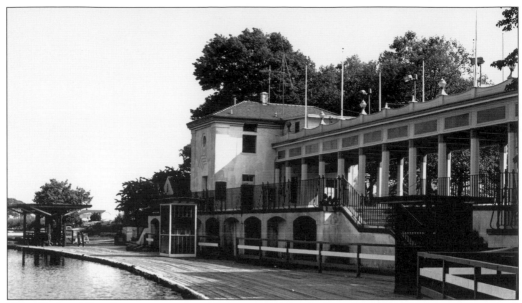

The Playland Boathouse in a picture from the 1980s looks a bit different from the original boathouse. Maintenance over the years to keep the building from deteriorating has caused the loss of much of the original detail and charm. In a project begun in 2006, the boathouse was largely rebuilt and renovated to return it to its original form. The restoration project cost a little less than $2 million. In particular, the murals painted on the upper part of the structure, obviously missing in the photograph above, were painstakingly replicated. With the historic renovation, the boathouse received the 2007 Citation Design Award for architectural excellence in historic restorations and adaptive reuse from the American Institute of Architects.

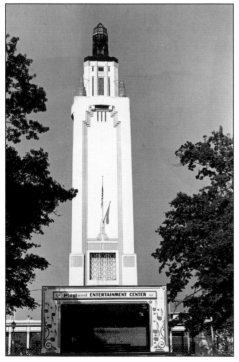

The Playland Music Tower in the photograph at left, also from the 1980s, remains the focal point for entertainment in the park. Musical groups still entertain patrons. The Playland Review entertains at the park daily. Other acts and musicians are scheduled as free concerts throughout the season. The singers are once-popular entertainers who can still draw a crowd and newer artists just starting out, such as the recent appearance in August 2007 of Teddy Geiger, a singer popular with young people of the time.

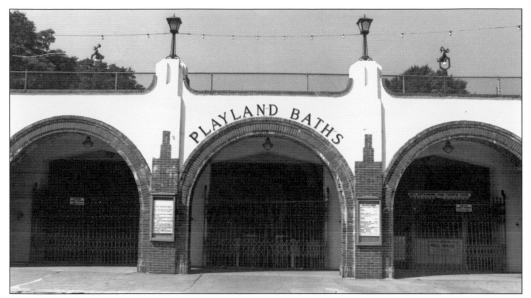

The beach entrance to the Playland Bathhouse is pictured above in the photograph from the 1980s. Out of use for more than 40 years, the building is getting ready for a new life as the Westchester County Children's Museum. Recent interior renovations have begun to get the building in shape. Architects and designers have been chosen. Once built, the Westchester County Children's Museum will be an exciting hands-on learning laboratory where children and adults can explore all that the special location, history, and culture have to offer.

It is fitting that the last image in this book be of the plaque permanently affixed on the mall at Playland that states that "This property has been placed on the National Register of Historic Places by the United States Department of the Interior." Playland received this status in 1987. The grounds are still well maintained. The view along the mall to the music tower at the far end is edged by the now fully grown trees. Playland is still a popular, family-fun place.

ACROSS AMERICA, PEOPLE ARE DISCOVERING SOMETHING WONDERFUL. *THEIR HERITAGE.*

Arcadia Publishing is the leading local history publisher in the United States. With more than 3,000 titles in print and hundreds of new titles released every year, Arcadia has extensive specialized experience chronicling the history of communities and celebrating America's hidden stories, bringing to life the people, places, and events from the past. To discover the history of other communities across the nation, please visit:

www.arcadiapublishing.com

Customized search tools allow you to find regional history books about the town where you grew up, the cities where your friends and family live, the town where your parents met, or even that retirement spot you've been dreaming about.